EDMUND DE WAAL

Edmund de Waal is an artist who has exhibited in
museums around the world. His bestselling memoir,
The Hare with Amber Eyes, has won many prizes
and been translated into 30 languages. He lives in
London with his family.

Instagram: @edmunddewaal
www.edmunddewaal.com

ALSO BY EDMUND DE WAAL

The Hare with Amber Eyes
The White Road

EDMUND DE WAAL

Letters to Camondo

VINTAGE

1 3 5 7 9 10 8 6 4 2

Vintage is part of the Penguin Random House group of companies
whose addresses can be found at global.penguinrandomhouse.com

Penguin
Random House
UK

Copyright © Edmund de Waal 2021

Edmund de Waal has asserted his right to be identified as the
author of this Work in accordance with the Copyright,
Designs and Patents Act 1988

First published in Vintage in 2022
First published in hardback by Chatto & Windus in 2021

penguin.co.uk/vintage

A CIP catalogue record for this book is
available from the British Library

ISBN 9781529114294

Printed and bound in Italy by L.E.G.O. S.p.A

The authorised representative in the EEA is Penguin Random House
Ireland, Morrison Chambers, 32 Nassau Street, Dublin D02 YH68

Penguin Random House is committed to a sustainable future
for our business, our readers and our planet. This book is made
from Forest Stewardship Council® certified paper.

For Felicity

lacrimae rerum

LETTERS TO CAMONDO

I

Dear friend,

I've been spending time in archives again. It is an early-spring morning and there is that barely suppressed immanence in the trees in the park. Few leaves yet but next week will be different. Too cold and wet to sit for long on one of the benches, but I do. Even the dogs aren't hanging about. It's been raining. There is a word for the smell of the world after rain: *petrichor*. It sounds a little French.

Everyone seems to be off and away at this hour. All this forward energy, propulsive.

I get up and walk along the damp gravelled path, out of the great gilded gates into the avenue Ruysdaël and turn left up the rue de Monceau. I ring the buzzer outside number 63 and wait for a response.

I'm going back to archives. That strong pull up to those rooms high in the attics, the servants' quarters, going back a hundred years.

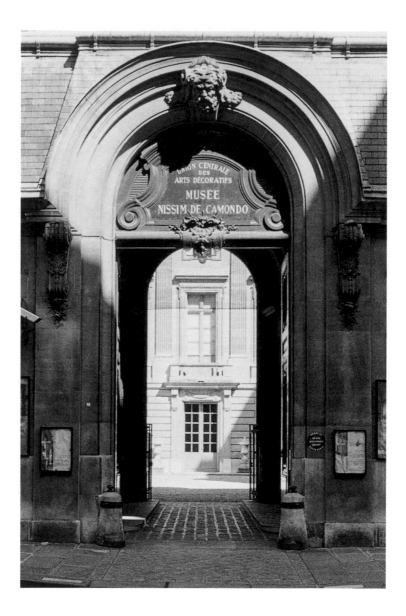

II

Dear friend,

I am making an archive of your archive.

I find inventories, carbon copies, auction catalogues, receipts and invoices, memoranda, wills and testaments, telegrams, newspaper announcements, cards of condolence, seating plans and menus, scores, opera programmes, sketches, bank records, hunting notebooks, photographs of artworks, photographs of the family, photographs of gravestones, account books, notebooks of acquisitions.

Each document is on a different kind of paper. Each has a different weight and texture and scent. Some have been stamped to show when a letter has been received and when answered. Archives are a way of showing how conscientious you are and it is clear that this is a place of discreet and powerful concentration.

Why is so much copied? Why carbon copies, almost weightless?

Here on the fifth floor of 63 rue de Monceau amongst the servants' rooms is a room lined with deep oak-panelled cupboards. It used to be *l'ancien garde-meubles*, the old storage room, according to the architect's plans from 1910. Each cupboard is full of ledgers and volumes of letters and boxes of photographs. Some ledgers are double-stacked. It is a whole world. It is a family, a bank, a dynasty.

I want to ask if you ever threw anything away.

I find the letters about excursions to restaurants with gastronomic friends. I find instructions to the gardeners for the annual replanting of the parterre, instructions to your wine merchant, to the bookbinder to keep your copies of the *Gazette des beaux-arts* in perfect red morocco, instructions for the storage of furs, instructions for the vet, the cooper, the florist. I find your responses to the dealers who write, daily.

Here are your notebooks of purchases. The first inscribed 'Before 1907 – 22 Novembre 1926'. Second one '3 Janvier 1927 – 2 Août 1935'. They are meticulous.

I find manifests for cargo, manifests for people as cargo.

I find the manifests for your daughter. For your son-in-law. For their children.

I find this difficult.

III

Dear friend,

As I am mostly English I want to ask you about the weather.

I want to enquire about the weather in Constantinople and out in the Halatte Forest where you hunt with the Lyons-Halatte in blue livery at the weekends and at Saint-Jean-Cap-Ferrat and out at sea. Gusty. I know that you had a rather splendid yacht but I'm not sure if that was a plutocratic purchase of obligation or pleasure. In fact, I want to know more about your obsession with speed. All that bowling along in the newest motor car with the wind buffeting you, the Paris to Berlin race, everything flying past as France disappears into the dust made by your Renault Landaulet. In 1895 you sit high up in a cap and goggles and a leather motoring coat, a blanket over your knees, and you are ready to take on the world. It is a sunny day. The shadows of the car are long. The road is empty.

I wonder about the weather in the paintings by Guardi that you have bought for *le petit bureau*, the small study. The gondoliers are straining against the wind past the Piazza San Marco. The pennants are flying. The lagoon is an empyrean jade.

I want to know about the porcelain room where your Sèvres services, *les services aux oiseaux Buffon*, are displayed in cabinets, on six shelves, and where you eat your lunch alone – do you look

out of the window and see the branches of the trees swaying gently in your garden and beyond it in the Parc Monceau? In 1913, you planted acer, Chinese privet and deep-red-leaved *Prunus cerasifera* 'Pissardii', cherry plum trees. You were thinking ahead, of course.

This is how the English ask how you are. We talk about the weather. And trees.

I'll ask again.

IV

Dear

I realise that I'm not entirely sure about how to address you, Monsieur le Comte.

As I shuffle through the letters from the dealers and the tradesmen soliciting your attention, your patronage in the matter of the anniversary exposition, your kindness in allowing us to remit this bill, you are addressed in various orotund ways. I like the collegiate greeting I found this morning from a friend from the Club des Cent inviting you to join him on a gastronomic adventure in a private restaurant car: *'Mon cher Camarade'*.

In these things I am caught between not wanting to offend and not wanting to waste time. *Monsieur* is possible and dignified and might lead to *Cher Monsieur*.

So I am not going to call you Moïse. And to call you Camondo sounds stentorian, a barked greeting across a library or dinner table. I know we are related in complicated ways but that can wait. So I am writing to you as *friend*.

We shall see how we get on.

I feel strange about signing off too –

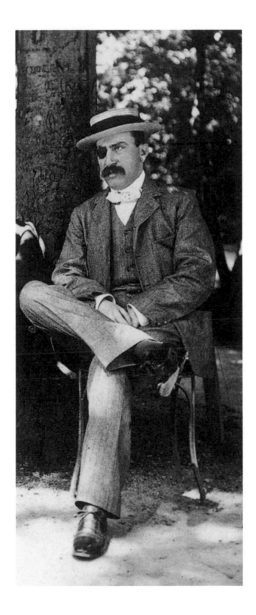

V

Dear *friend*,

I'd like to ask you about the carpet of the winds. It is in *le grand salon*, the large drawing room, overlooking the park.

It is one of ninety-three carpets woven at the Savonnerie manufactory between 1671 and 1688 for the Galerie du Bord de l'Eau in the Louvre. This is the fiftieth. The four winds puff their cheeks and blow their long horns and the air is knotted and ravelled with gusts of ribbons and Juno and Aeolus. There are crowns and more trumpets and cascades of flowers deliquescing and stiff acanthus framing it all and it is gold and blue; the colour of the wind along the wharfs of Galata, out at sea. This is early-morning stuff, bracing.

It used to be a longer carpet when you first walked on it in the house of the Heimendahls – fellow financiers – in the rue de Constantine, and when they were in some financial embarrassment you bought it from them. I'm pleased to find that Charles Ephrussi helped you buy it as he knew you and them, knew everyone, could deal with this sort of thing, charmingly, and made things happen. Charles is important to me, the cousin who set me off on my adventures.

And I suppose I want to know that you notice it. Notice that you are walking on air.

On exhalation.

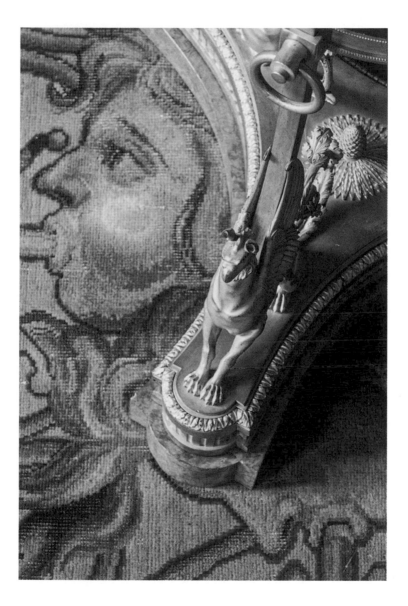

VI

Dear friend,

Because it is a Parisian spring out there I want to open all the windows of your gorgeous, golden house.

And there are a lot of them. The facade to the rue de Monceau is seven windows wide, modelled by your architect on the spare elegance of the Petit Trianon at Versailles, but rather brilliantly there are fifteen windows on the park side where the straight facade becomes two wings framing a grand semicircular bay supported by Corinthian pilasters. This is a house that you cannot understand without a plan. And forgive me this conceit but just imagine the air moving, reaching round these rooms and up that sinuous staircase, reuniting the winds in these paintings and tapestries and the carpet of the winds. And maybe starting with this golden carpet wasn't quite right but I'm feeling rather cheerful being here and I suppose I wanted to write to you about what is under your feet: if I could work this out then I could get a fuller feeling for where you start.

I've spent quite a few years in your company and it seems only sensible to talk about beginnings.

You were born in a 'stone house' at 6 Camondo Street in Galata in Constantinople and spent the first nine years of your life looking out over the Bosphorus. There was 'an adjoining pavilion

in which there is an oratory and baths, opposite the winter garden'. That is a pretty telling genesis. Not many people begin in a street with a familial name. Or indeed a palais or *hôtel* or palazzo, or a house with an oratory, but we will get to that in time. It's a bit of an issue. But *stone* suggests distinction. Then I find out a little more, that the whole of Galata seems to have been owned by your family, and that your grandfather was responsible for my favourite staircases in the world, those sinuous intertwined runs of steps, breathing in and out down a hillside. I had a photograph of this staircase by Cartier-Bresson above my potter's wheel for years. I'd look up, hands covered in clay, and think *elsewhere*.

If I'm obsessing about working from the ground up we could start with dust; I know that dust matters to you.

On 20 January 1924, in the 'Instructions and advice for the curators of the Musée Nissim de Camondo', you write:

I wish my museum to be admirably maintained and kept meticulously clean. The task is not an easy one, even with the first-class staff, of whom there must be a sufficient number for this job; but the work is made easier by a complete vacuum cleaning system which works cheaply and marvellously well. Due to its powerful operation, this method of cleaning should not be used for antique carpets, tapestries and silks but is of great benefit.

Your house is so clean, so charged in its defences against dust. You don't want time to change anything, light to fade the tapestries, heat to warp the veneered furniture, the panelling, the parquet floors, dust to damage the collection. You also worry about damp.

On rainy days, the public should enter via the wrought-iron doors from the covered motor car entrance linking the courtyard to the mews that leads to boulevard Malesherbes. The door is approached via a wide paved area which could be covered with matting and where one could place umbrella stands.

The weather must be kept out, the windows kept closed. We need to talk about this again.

VII

Dear friend,

It is not that I don't like being clean, it is just that I'm drawn to dust. Dust comes from something. It shows something has happened, shows what has been disturbed or changed in the world. It marks time.

A few years ago I was asked to be part of an exhibition about Giorgio Morandi. I went to Morandi's apartment in the via Fondazza in Bologna where he lived for thirty years, with his mother and sister, his modest studio through a door off the dining room. Here he arranged and rearranged his votive jars and vases and painted tin cans into still lives, marking down their choreographic positions in pencil on the tables he had made. And over these objects, wrote John Rewald, a visiting art historian, was

a dense, grey, velvety dust, like a soft coat of felt, its colour and texture seemingly providing the unifying element for these tall bottles and deep bowls ... It was a dust that was not the result of negligence and untidiness but of patience, a witness to complete peace ... The dust that covered them was like a mantle of nobility ...

You live without negligence or untidiness but I hope you might understand the 'witness' element of this. I am sure the 'mantle of nobility' will speak to you.

Without dust, Monsieur, it is harder to find the traces.

I look back at the traces of my own family and think of how they started out in a shtetl – dusty – and then moved to Odessa on the Primorsky Boulevard overlooking the Black Sea. And then on to the Ringstrasse in Vienna and to the rue de Monceau – ten houses up the hill from where you live, here in Paris – and think that they must have been living in one vast building site after another. Unpaved streets and the horses and carts and carriages and the stonemasons working outside the house and in, and then the carpenters and plasterers and painters and gilders, each producing their own clouds of particular dust, foul in winter and worse in the summer. With the fires in every room and the gas lamps that give off that sweaty sootiness and then the Second Empire soft furnishings – all those padded seats, all that operatic nonsense around curtains and blinds and pelmets and trailing swags – there must have been dust settling everywhere.

To keep dust-free you need to be rich and exacting and have servants to endlessly sweep away all those traces that might show where you have come from.

This is the parallel, dusty journey of our families.

I'll give it a rest.

VIII

Monsieur,

'Ash ... the very last product of combustion, with no more resistance in it ... [represents] the borderline between being and nothingness. Ash is a redeemed substance, like dust,' wrote W. G. Sebald.

I don't quite understand these words, but they haunt me. They feel close to the heart of what I need to ask you.

IX

So, Monsieur, I need to look for the traces.

I've read as many books as I can find and catalogues and scholarly articles, some of which make sense. I've found myself returning to all my old habits, moving my Paris books down from the top shelves to be near at hand, searching notebooks from twenty years ago. The Goncourt journals are back. Proust is back, and some Balzac, and Huysmans, though I'm not sure I can face him again. And I can promise you that I really have done the legwork on the way that the taste for *japonisme* changes in Paris, the salons and the *salonnières*, the Dreyfus Affair of course, Edouard Drumont and the anti-Semitic press, duelling, Bizet, beards, moustaches, flâneurs. I can walk with you through the Jewish mansions of the Plaine Monceau. I know far too much about who my cousins slept with a century ago.

The archives in the attics help but now I need to look for those things that have *not* been catalogued and filed and photographed. You were pretty definitive in your wishes for this gift of the house and collections, decisive in the planning about where you want visitors to go and what they can see.

And what is off limits.

I *haven't* written to say that there are a few things that I just don't like in the house, Monsieur, as that seems a little graceless.

But the bacchante stuff doesn't age well. And then there is that really ghastly nude above your bed. It is an allegory of sleep apparently but it is pretty charmless, to be honest. This isn't really about taste. It is more that these suites of great rooms are so carefully calibrated that there is a consequential gravitational pull up and down, to the attics and to the cellars, the stuff you didn't want us to find, the stuff that survived your editing, your prohibitions. I'm in search of that.

When I was tracing my own family I only truly understood the Vienna house when I stood in the cellars and looked up into the dizzying spiral of the service stairs, the hidden circulation of people that made it work, kept it afloat.

So I start in the kitchens and work my way through the house avoiding the public spaces. Your architect René Sergent had just finished refurbishing Claridge's in London when he designed these spaces and they are the last word in efficiency. The ventilation and plumbing are just so, the scullery doorknobs grooved to fit the hand of a kitchen maid in a hurry. The white faience tiling gleams. The cast-iron range looks as sleek one of your new motor cars in the vastness of your garages. All the windows have frosted glass. The light is subdued.

The door to the service stairs is discreet, barely noticeable. A feathery arrow under the *escalier de service* points the way to a metal staircase wrapped around a central lift. I go up. The first door takes me into the butler's pantry with its zinc sinks for washing glasses and plates. A hidden door leads into the dining room. On the next floor is the butler's suite of rooms, his second pantry and the silver room with its empty velvet-lined shelves for cutlery.

Pierre Godefin enters your service in 1882 as butler to your uncle and stays here till 1933. He gets clear glass in his windows and a view of the park through the trees. There is a board to hold all the keys. He sits here and orders turpentine and chamois leathers and tissue paper and horsehair brushes and crystals and Buhler paste and knife powder and Curémail and green soap and floor cloths and Goddard powder and alcohol and straw brooms. Monsieur Godefin orders jam from Fouquet's and *petits fours* from Boissier. He knows you.

The next floor and the housekeeper's room, a window looking out into the courtyard. And beyond it *habillage de Mlle*, the rooms for your daughter Béatrice, and in the shuttered light there is a marble column with a luggage label tied to it and furniture under a dust sheet, an abandoned chair, something that needs repair. The wallpaper is delicate, green, entwined flowers: perfect for a young woman's bedroom. Her bathroom is untouched. A frieze of delft landscape tiles between two yellow bands runs round the room. Her bath is in an arched alcove. Shadows hold it all. I close this door very carefully.

The fifth floor, the attics – room after room for linen, for washing, one for luggage, one for trunks. The servants' bedrooms and bathrooms. The dressing rooms with the deep oak wardrobes where your clothes were stored and that connect your bedroom and your son Nissim's with discreet spiral stairs, *escalier du valet de chambre*. This is where the archives are now.

The stone balustrades that hide the roofline from the park and the street mean that light only reaches in at head height. There is a cupboard with broken light fittings laid out. Some more broken

chairs. I open a door and find Louis Vuitton luggage from the 1920s.

A bench in a corridor is labelled *l'Art Nouveau Bing 22 rue de Provence Paris*. A bent enamel label, *Toilettes Fils domestiques*, is nailed at floor level in an empty room, washed pink. A door handle with a label F1. Emptiness.

Remember this. Holding on to the thread, it passing through your hands, a skein, it twists back on itself. It seems to weigh nothing, disappear. Holding the story, your story, Monsieur, Ariadne's thread.

X

Dear friend,

As you may have guessed by now, I am not in your house by accident. I know your street rather well.

Actually – if I can put aside that Englishness for a minute – I know it *really* well. It is just that I'm a little embarrassed by how much time I've spent in the rue de Monceau, how many days I've spent reading about it, haunting it.

It started twenty years ago on a morning not unlike this one. I'd walk slowly up one side of the road from the boulevard Haussmann up to the rue de Courcelles, to the stretch where it starts to get interesting, and then past the small turning into the Parc Monceau, a green glimpse at the end of the avenue Ruysdaël. Then past your uncle Abraham's vast 'monstrosity' at 61 and your elegant gates at 63, up to the boulevard Malesherbes, and over into the golden hill of mansions to stand – or loiter, you might say – outside number 81, the Hôtel Ephrussi, ten houses up from the Hôtel Camondo.

I had inherited a collection of Japanese netsuke – 264 small, intricate and seductively touchable ivory and wood carvings – from my beloved Jewish great-uncle Iggie Ephrussi and the compulsion to understand where they had been in my family history had taken me over. This collection started here. It was bought by your friend

Charles Ephrussi, and kept in a vitrine in the suite of rooms that he occupied alongside paintings by his Impressionist friends. The story started in the rue de Monceau. It took me on a journey across Europe and back two hundred years. Now when I return I stand outside and lay a hand on this house affectionately.

And what makes this street so special is that this is a street of conversations, a street of beginnings. No one is here by chance. It is part of a new development in an undistinguished part of Paris when it is laid out in the 1860s by the Pereire brothers. There is a park already here that they remodel in the English manner with a little lake and bridge and smart flower beds full of annual flowers that need to be tended and renewed and weeded so that there are always gardeners head down and meandering paths where 'the great dames of the noble Faubourg ... the female "*illustrations*" of "*La Haute Finance*" and "*La Haute Colonie Israélite*" promenade'. There are benches, useful for assignations. But over time the park becomes a little cluttered with fountains and monuments: Maupassant is here with a reclining devotee; Gounod has three of them looking tragic; Ambroise Thomas and Alfred de Musset make do with one apiece. Chopin wins by getting a piano too.

The park keepers unlock the black-and-gold gates at six. They are splendid gates.

The Jewish families who move to this district come from elsewhere. This place offers a chance to bring your family to secular, republican, tolerant, civilised Paris and build something with self-confidence, something with appropriate scale, something public. Both our families, the Ephrussi and the Camondo arrive in 1869 – mine from Odessa, yours from Constantinople – and both our

families buy plots of land in the rue de Monceau that same year. At number 55 is the Hôtel Cattaui, home to Jewish bankers who have moved from Egypt. There are a couple of Rothschilds over the road and two of the three plutocratic and scholarly Reinach brothers live right next to the park. Henri Cernuschi, who lives diagonally across from you, isn't Jewish but is in exile from Italy for his political views. And there are artists and writers here. At number 31 Madame Lemaire holds a salon on Thursdays where the throngs can admire both her watercolours of flowers and themselves. Proust grows up round the corner and plays in the Parc Monceau, baked potatoes in his pockets in winter to keep him warm. Theodor Herzl, the architect of Zionism, lives at 8 rue de Monceau during the Dreyfus years.

Even today it is still pretty chic. It was the start of school as I made my way to the archives first thing this morning and the street was full of children with parents and au pairs and a ridiculous quantity of small dogs with their eddies and pulses of interest and retreat. A street full of conversation, and cups of coffee.

This is a Londoner writing to you. We live opposite a school and our street is full of huge cars and slammed doors at this time of day, dammit.

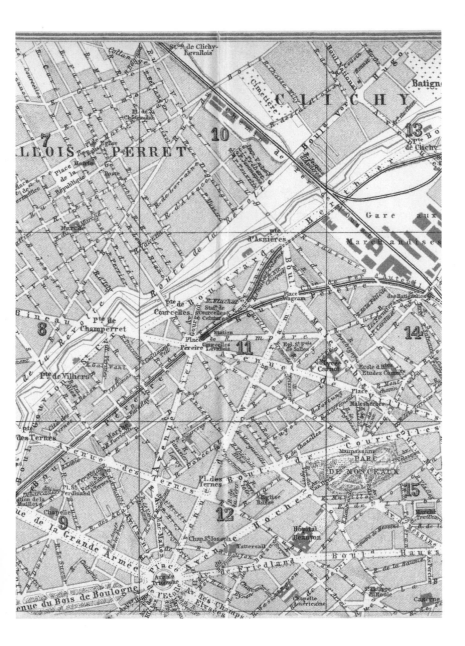

Dear friend,

Your family arrive in Paris at the same time as my family.

Well, *snap*, as one of my sons says.

Your father Nissim de Camondo and your uncle Abraham-Behor acquire two adjoining plots of land on the edge of the Parc Monceau. Your father commissions the achingly fashionable Denis-Louis Destors to reconfigure the existing mansion at 63 and at number 61 your uncle Abraham commissions Destors to build a vast mansion with Corinthian pilasters and a handsome mansard roof surmounted by a glass lantern on top of it all. And a weather-vane. There is a substantial glass canopy so that you are protected from the elements. The garden front facing the park has some caryatids and there is a conservatory that is almost two storeys high.

In *La Curée*, published in 1871, Zola, acidly, describes one of these mansions as 'still-new and pale' and 'an opulent bastard of every style'. In this novel Saccard, a rapacious financier, lives in such a house, scheming and speculating. The roof of the mansion, Zola notes, is a 'climax of this display of architectural fireworks'.

There is a portrait of your cousins with their governess in your father's house at number 63. It shows them among palm trees and heavy, upholstered, carved furniture, on a Persian carpet, with

some vaguely classical sculpture and random *japonaiseries* – a bronze tortoise and a bronze stork eight feet high.

Walter Benjamin described the arrangement of furniture in a mansion like this as 'the site plan of deadly traps: the suite of rooms prescribes the path of the fleeing victim'.

Above the chimney piece in the vast suite of enfilade rooms is a clock with bronze figures symbolising Prosperity. There are coffered ceilings enclosing allegorical scenes of Science and Industry and the Triumph of Civilisation, and chandeliers, and each chair is a princely throne. The staircase emulates that of the Opéra Garnier. It is one thing on top of another: caryatids support gilt-bronze consoles supporting vase-shaped gas torchères. There are Dutch paintings and Chinese porcelains. There are four seventeenth-century Flemish tapestries depicting the Crossing of the Red Sea, the Golden Calf, Moses and Aaron, and Joseph with his Brothers. Everything in this house is capitalised, underlined, illuminated.

There is a smaller *hôtel* for Abraham's son Isaac, your older cousin and friend, across the courtyard.

The Camondo houses can only be glimpsed over the high walls adjoining the rue de Monceau. 'On summer nights, when the sun's slanting rays lit up the gold of the railings against the white façade, people strolling in the park stopped to stare at the red silk curtains hanging in the first floor windows,' writes Zola. There is also a wildly anti-Semitic novel by Guy de Charnacé, about the family of a Jewish banker, titled – yes – *Le Baron Vampire*. 'The Parc Monceau, which neighboured his property, troubled him; he did not doubt that he would acquire it at some point, from some commune.'

And, Monsieur, I look at all this and I know it. It is our family house in Vienna, the Palais Ephrussi. Jewish themes – the Destruction of the Enemies of Israel, the Coronation of Esther – painted on the coffered ceiling of the ballroom; a statue of Apollo in the courtyard, marble and gold and grandeur. You cross the threshold and there is a double E for Ephrussi inlaid into the floor. Everything in this house is capitalised, underlined, illuminated.

Everything is dynastic, a site plan of deadly traps.

I think there might be more caryatids on our palais.

Snap.

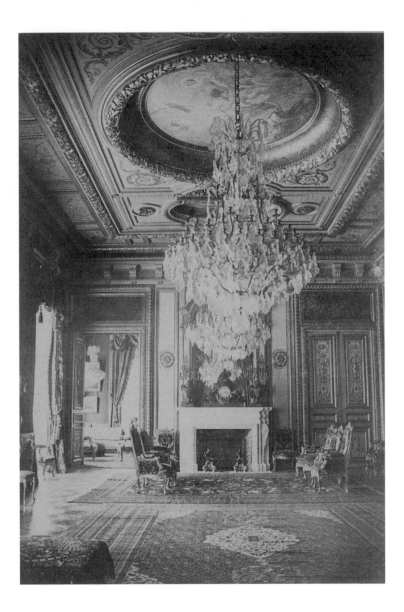

XII

Monsieur,

Everyone here around the Parc Monceau seems to be a cousin. It seems best to assume so.

You do business with X and take a month at Aix-les-Bains with Y and hunt with Z. There is the synagogue for bar mitzvahs and the marriages – arranged – of children, for funerals and the festivals. Your fathers worked together on deals on grain or railroads fifty years ago. Your mothers helped someone's daughter find the right connection. Why wouldn't you help place a younger son, put his name up for a club?

As this is Paris these clans are complex. And yours – ours – are Byzantine, Levantine.

I could begin anywhere but I'll start with Louise Cahen d'Anvers. She deserves to come first.

Louise is beautiful with red-gold hair, 'golden, like the painting of THE MISTRESS OF TITIAN', notes Edmond de Goncourt in his journal, after visiting her salon. No one can be compared lightly to that painting of a golden and languorous woman. He notices her 'fishing in the bottom of her vitrine of porcelain and lacquer, wanting to hand me some; she moved like a lazy cat'. She is '*La muse alpha*' according to the novelist Paul Bourget, the centre of a shifting constellation of writers, artists, *mondains*.

Louise is married to Louis Raphaël, Comte Cahen d'Anvers, a Jewish banker, and has four children and lives in glory in the Hôtel Cahen built by Destailleur on the corner of the rue de Bassano and the avenue d'Iéna in the 16th arrondissement. They have bought the beautiful Château de Champs-sur-Marne too and they are restoring it with panache.

If you buy or build on this scale you need to furnish appropriately too and this might be a good moment to talk with you about portraits. I'm overlooked as I write this by my great-grandmother painted in Vienna in the 1880s by Angeli. She is disdainful. She wears a lot of pearls. Angeli was good on pearls: he knew his clientele. I think of your family and mine and their need to get portraits, see where they came from. If you haven't got a long corridor in some windy *Schloss* with those cascading generations on show then you better start now, get a move on. In Bourget's novel *Cosmopolis,* a visitor to a newly ennobled Jewish collector's house remarks that 'Yes, there are two magnificent portraits of ancestors, and this man has no ancestors!'

If you sit for Carolus-Duran in his studio on the boulevard du Montparnasse he will make you salon-ready. He is good on beards and makes women look very tall. He has done your uncle, your father, most of the Cahen d'Anvers – Louise looks gorgeous – and any number of American heiresses.

Louise's lover *was* Bourget which might explain his snide remarks about ancestral portraits but is *now* Charles Ephrussi. Edmond de Goncourt who seems to be everywhere encounters Charles and Louise huddling together in the back gallery of a fashionable dealer in Japanese art. He buys the netsuke collection with her, for her,

to impress her. Together they collect Japanese lacquers, go to the Opéra, to salons and endless parties. When Louise has another son she names him Charles, which seems pretty nonchalant and sophisticated about domestic arrangements to my bourgeois Englishness.

Charles Ephrussi tries to look after his impoverished artist friends. He collects, generously, the works of Degas, Pissarro, Morisot, Sisley, Monet, Renoir, writes about them, cogently, in the *Gazette des beaux-arts*, advises them on exhibitions. And he helps by introducing his *mondain* friends to them, persuading them to commission portraits. Two of his siblings and an aunt get painted by Renoir and then Charles persuades Louise to have her children painted too.

Irène, the eldest daughter, is the first subject in 1880 when she is eight years old. She is shown with long reddish-golden hair falling over her shoulders and down her back held with a single blue ribbon. She looks pensive, a little bored, hands demurely clasped in her lap, dressed in a dress of silver and blue. She is sitting in the garden of the house in the rue de Bassano.

The younger girls, Alice and Elisabeth, are painted the next year. They are six and five years old, in party dresses of pink and blue ruffles with lavish matching sashes, holding hands for reassurance, a great curtain behind them. They are two children stranded in some vast domestic salon.

And, eleven years later, you, Monsieur le Comte Moïse de Camondo marry the girl with the long red-gold hair, Mlle Clara Irène Elise Cahen d'Anvers.

Irène has just turned nineteen and you are thirty-one.

XIII

So, Monsieur,

Not to go on about this too much but yes, she is only nineteen and you are thirty-one, and this is a properly dynastic union.

According to a newspaper's breathless account of your wedding on the 15 October 1891 the bride wears *'une toilette en satin blanc, garnie de vieil Alençon posé en biais sur la jupe et retenu de distance en distance par des bouquets de fleurs d'oranger'*. The witnesses and guests – a list of Rothschilds, Oppenheimers, Foulds and Ephrussis – return from the synagogue to the Hôtel Cahen d'Anvers for lunch and that evening you depart to Cannes where 'you will stay till May'. A good eight-month honeymoon, then.

You have considerable knowledge of the family business, speak perfect English, ride well to hounds, have a rather dashing eyepatch due to a hunting accident and by all accounts are terrifically good company. But I struggle to find out much about Irène, except that she rides.

Charles Ephrussi lends you and your young wife an apartment in a vast building they have moved to in the place d'Iéna. It is two hundred metres from another Ephrussi mansion and the same from your mother-in-law's *hôtel*. It is all *very* intimate.

Irène moves two hundred metres from her parents. I thought I'd repeat that.

You and your father-in-law buy a huge yacht together, *Le Geraldine*. You also buy your first car, a Peugeot with a Panhard-Levassor engine.

Your son Nissim is born one year after your wedding, your daughter Béatrice two years later.

I thought that I'd left all this flâneuring around Paris forever – I do have other interests – but here I am again in your street, this hill of families, writing to you, talking to the dead, archiving.

Over the last twenty years I seem to have acquired an awful lot of cousins. I get letters.

XIV

And, Monsieur, six years later Irène runs off with Count Charles Sampieri, in charge of the Camondo racing stables and her riding instructor. The only picture I can find shows an elongated figure in a top hat at the races, one gloved hand holding a malacca cane. He has a fair moustache and I don't trust him. Rather gallingly he is practically the same age as you. She converts to Catholicism.

Your divorce is miserable and public and very long-winded. It isn't finalised until 8 January 1902. The two children are to live with you. You sell the yacht.

On 4 March 1903 your ex-wife writes to the children:

Mes chéris, comme je vous l'ait dit l'autre jour, je vais m'absenter pendant quelques semaines en Italie. Je vous annonce une nouvelle qui ne vous étonnera pas, car vous vous y attendiez! Je me suis mariée l'autre jour avec M. Sampieri.

So *that* is how you tell children about your absence for the last few weeks. And about your marriage.

The Count and Countess Sampieri have a daughter, Claude Germaine, in December. And then they separate.

All for now, I think. More than enough for a letter. Sorry about this.

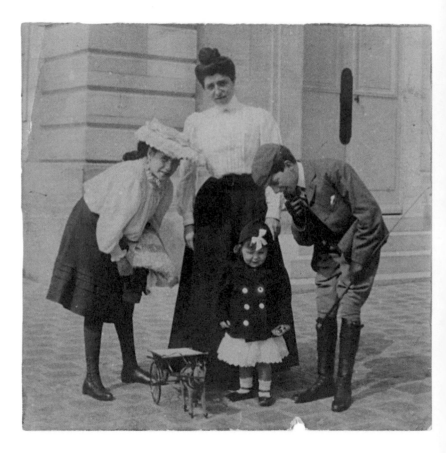

XV

Actually, Monsieur, on families and cousins and dynasties I'd just like to point out that Edouard Drumont, the hugely popular cheerleader of French anti-Semitism, assumes that we are all related.

'*Les Rothschilds, Erlanger, Hirsch, Ephrussi, Bamberger, Camondo, Stern, Cahen d'Anvers … Membres de la finance internationale*' are living too grandly, inappropriately, says Drumont. His wildly successful *La France Juive* goes into two hundred editions. *They* are all cousins, he says. *They* are cosmopolitan, from elsewhere, not properly French, just pretending.

This is how Drumont works. Every Jew is responsible for every other Jew, culpable. And treacherous. *L'affaire Dreyfus* makes us all cousins.

L'affaire gives even greater prominence to your neighbours the Reinach brothers.

They are formidable scholars. Their nickname, coined in a popular song, is 'Je Sais Tout' (Joseph, Salomon and Théodore). They are 'the Know-It-All Brothers'.

Joseph, the eldest, trained as a lawyer before becoming a campaigning politician, advocating for the abolition of public executions. He is a passionate defender of democracy and republicanism: France is the country of tolerance, the country of equality.

He is a powerful supporter of Dreyfus, reporting daily on his trial, and writing the most authoritative account of the Affair. He has been beaten up by anti-Dreyfusards, has duelled for his honour, is attacked daily in *La Libre Parole*. People write to say how they would like him to die. Actually, *priests* write in exhorting him to be thrown into the sewer, skinned alive, put in a cattle truck. *Reinach* becomes synonymous with Dreyfus: 'with Reinach beaten, Jewry is dead; with Drumont elected, France is reborn. Long live France for the French!'

Salomon is an archaeologist and cultural historian. He is fiercely rationalist, writing on how myths survive and change, why we believe and the dangers of belief. He is wide-ranging in his denunciation of pogroms and inquisitions, of the resurgence in Catholic-sanctioned anti-Semitism. In his book on Orpheus he writes of

judicial murders, the accursed fruits of a spirit of oppression and fanaticism ... There are zealots among us who still glorify these crimes, and would wish to see them continued. If they attack my book, they do it and me a great honour ... Modern civilization need not be alarmed by these survivals but it must not ignore them.

Salomon is fearless, publishing a pamphlet that lists Drumont's mistakes in measured prose.

And Théodore is the last son. He seems to write with serious focus on everything from archaeology to music, and from Jewish history to numismatics, a public figure, on this commission and that institute, panoptic in interest and reach. He is also a powerful voice for assimilation as Secretary General of the Société des études

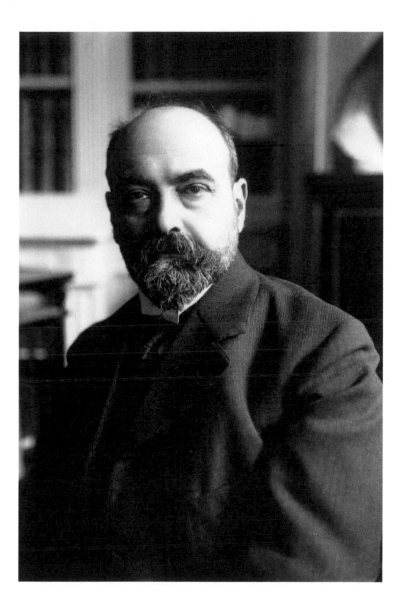

juives and the founder of the Union libérale israélite. He advocates for a 'silence of disdain' towards the Drumonts of the world. You must never allow yourselves as a Frenchman and a Jew to be brought down to invective, name-calling. It is a terrific phrase and he lives it. Théodore is stocky and balding. He holds my gaze.

Reinach means you are conspicuous, cosmopolitan, endlessly attacked as inauthentic:

you can't turn to some Leven or Reinach and naturalize his style as you naturalize his person; you must be suckled on the nation's wine from birth, you must have truly come out of its earth. Only then ... does your phrasing have a taste of the soil, drawn from a common bedrock of feelings and ideas.

The Reinach family come from Alsace: how can they speak as Frenchmen do, be really French? In France *Reinach* means Jew.

And your son Nissim goes to school, the Lycée Janson-de-Sailly, with Théodore's four sons, Julien, Léon, Paul and Olivier.

Reinachs, Camondos. *Cousins.*

XVI

Cher Monsieur,

Horses.

Lots of horses and dogs and the hunting in the autumn and winter, the rain early and the cold and the scent lifting in the forests. You hunt with the Lyons-Halatte, *'par monts et vallons'*, over hill and dale. The livery is splendid, *'en redingote bleue, coiffés de bombes noires'*. Women wear tricorn hats.

You do love this. I transect your house and see the traces. You buy the cartoons Oudry painted for the Gobelins tapestries to be made for Louis XV's apartments at Château de Compiègne. These tapestries are to be vast and show the king at his very best, towering above others on horseback. The king does not hunt alone and so among the trees are members of his court waiting for him to lead off and away with horns and the dogs. And there are the paintings of the hunt in Nissim's bedroom, the sculpture and photographs of Béatrice on horseback.

After the divorce you buy a vast estate with forests near Chantilly. And you rename the mansion Villa Béatrice, which is rather touching. In the stables are your hunters Pacha and Jack and Patto and the mare Mayqueen and the ponies Sambo and Charlie and two donkeys. And there are runs of buildings for gigs and carriages.

Gun rooms and cold stores for game and all that palaver. The estate has strict enforcement against poachers.

I'm in the archives again. I turn the pages of your hunting journals, the lists of who came, the game you caught, who you sent it to. The *chasse du 22 sept plaine de Malassise* in 1909 records that there are eight gentlemen who join you on a shoot including Monsieur Jules Ephrussi and you slaughter 102 partridge and 10 hares. I'm not impressed by shooting hares.

Who should hunt in these ancient forests? shout the daily anti-Semitic screeds of *La Libre Parole*, the popular newspaper dedicated to exposing the deceit of the Jews. Hunting is an ancient right, says Drumont in *La France Juive*, and this is trespass. And he goes on: 'the spectacle of all those bearers of noble names dragging themselves, under the ironic smiles of the servants, following the hunt with some grotesque Jew from Germany or Russia who kindly invited them'.

This is what is wrong: the Jew on horseback. Who hunts, who should be hunted?

Horses are part of your life. Your black eyepatch over your right eye is a trophy of a hunting accident in your youth. It looks rather distinguished and makes it easy to spot you in society cartoons. But horses *are* Béatrice's life. She is fearless, an eventer as well as a hunter. She passes on this love to Fanny, her daughter, your granddaughter.

In the last photograph of your granddaughter in the archive she is on horseback.

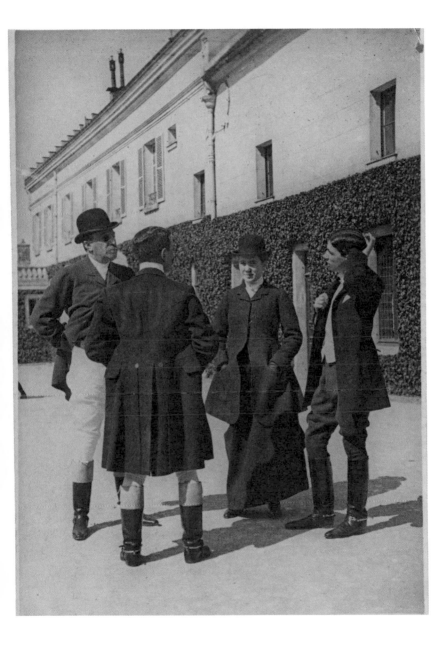

XVII

Dear friend,

I thought I'd leave all that marriage stuff behind as I've got to ask you about selling everything that you inherited.

It is quite startling to read that you sent off to auction all the paintings of mosques and courtyards and houris that your father loved.

Off goes Pasini's *Entrance of a Mosque in Tehran*. Lot number 31 on 18 November 1910 as part of three days of cleaning the decks at the Hôtel Drouot. Off goes (for very little) *The Courtyard of a Paris House*, *The Sack of Sancta Sophia in Constantinople* and all the *tchibuks* and hookahs and every other bit of Ottoman texture and patterning that he had in the house. The jewellery and the *objets d'art* and the paintings go into the world, one lot after another after another.

And then you start to give away pretty much everything else that connects you to Constantinople. The oratory in your father's house is stripped. Could there be a more biblical phrase? And you donate the ornamental plaque for the Torah given to you on your bar mitzvah, and the *rimmonim* for the Torah scroll, in engraved gold, and the lamp of reconsecration given by David Sassoon to the Camondo family in 1864. You give the *coffre à rouleau de Torah* with its Hebrew inscription, 'the notable, the esteemed, the superb,

the lord, the influential prince of Israel, R. Senor Abraham of the line of Camondo', to Temple Buffault, and four pieces of Oriental and Dutch silverware used in Jewish worship to the Musée de Cluny.

When you have auctioned off or donated to museums and synagogues pretty much the whole of your material inheritance, I try to work out what you actually kept and why. A set of nice silver-covered dishes that must have been useful. Some large and valuable Chinese porcelain vases bought from the sale of your uncle's collection. A couple of flambeaux. Four embroideries sit in the panels of the false door from the dining room into the butler's pantry.

And then, of course, you pull down the house your parents built in the rue de Monceau and start to make plans for your own.

This new house will not be so visible. It will have none of the operatic presence of your parents' house but will be contained in a restrained courtyard, a house of seven bays, Corinthian pilasters, a modest balustrade. It will be modelled on the Petit Trianon.

XVIII

And forgive this addendum, Monsieur le Comte, but on the subject of giving things away I have only just discovered that you also donated a collection of fifty-five tiepins, *les épingles de cravate*, given to your father by his lover, the Comtesse de Lancey.

They were together for ten years. The comtesse had shed several identities. She began as Julia Tahl in Baltimore. Then became Julie Eardley-Wilmot, divorced. And then, rather mysteriously, transformed into Alice, Comtesse. I rather respect the change in first name alongside the serial divorces.

She has, of course, been painted by Carolus-Duran. She reclines upon a chaise longue against a huge red cushion. One hand holds a fan, the other frames her face. She looks directly at us. She is wearing white silk satin embroidered with pearls. Her shoes have gold heels. The critics have decided that this painting is the height of vulgarity, but my God, she has style. She has bought the *pavillon de musique de Madame Du Barry* in the grounds of the Château de Louveciennes and she is now restoring this elegant pavilion with the brio of a WTF heiress from Baltimore. The Goncourt brothers acidly remark that she has displaced Madame Du Barry and Camondo has taken the place of Louis XV. Seeing the slightly dour portrait of your father also by Carolus-Duran, described as

'cunning and pallid' by some anti-Semitic hack, I struggle to see him as Louis XV.

These tiepins, by Boucheron, are expensive and fashioned from lapis lazuli, onyx, jasper, pearls, sardonyx, labradorite, opal so that you can look like a Renaissance prince at the Bourse, or at Longchamp or at the Opéra. Or, cuttingly, in the description of a Jewish banker in *Le Baron Vampire* with his 'cufflinks, buttons on his shirt, buttons on his waistcoat, all made of emeralds; it is a jewellery display ... '

A tiepin is a rather good present: small and precious and pointed. You give them all away to the Musée des Arts Décoratifs in 1933.

A beautiful, exact, sharp donation.

I find I'm jealous of your definition, in the ways you made this space for yourself.

XIX

Monsieur,

I cannot help but notice that you like furniture that changes.

In the small study is a mechanical table *à la Bourgogne* made by Roger Vandercruse in oak and walnut veneered with bloodwood and amaranth and tulipwood and holly and chased and gilt bronze. You press a button and a section rises, sighingly. You press this panel and a drawer exhales.

These are surfaces to be caressed and let go, pressed and released. Drawers for secrets, a desk for the life you keep close. You open to a vacancy.

And here is a table *à la Tronchin* attributed to David Roentgen that hinges up so that you can stand and be important. Maps of campaigns, plans for the new wing. It all works perfectly.

Your house is a place where everything is something else. It is a baroque riposte against truth to materials; here one material segues into another, your hand touches gold on the arms of the chair on which you sit. There are plaques of porcelain set into the furniture. This is an interior as performance in which you too are a protagonist, catching sight of yourself in the mirrors. Everything is multiple, mirrored, paired, reflected, repeated. This great slow cadenced repetition of candelabra, vases, firedogs, pier glasses, tables, chairs and the *guéridons* – it all comes alive as you move

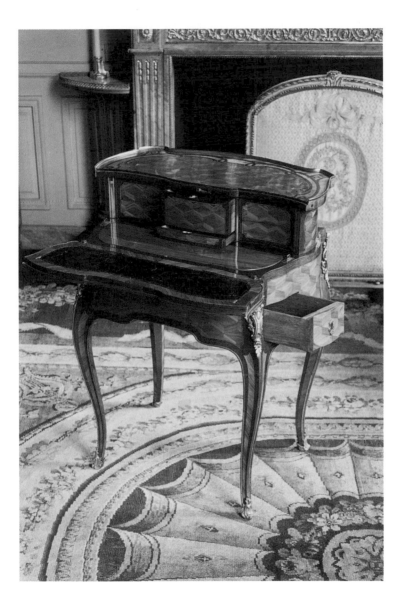

through the space. Objects are not seen by themselves but discovered among others.

In this house one room leads onwards, unfolds, interlocks. I stand in your library and can go in three directions. The grand salon leads to four other spaces. There are alcoves and spiral staircases from bedrooms up to the servants' rooms so that clothes can appear and disappear. You catch sight of a winding staircase arcing up, bisected by a balcony. There is a hidden suite of rooms for the butler, a silver chamber, a separate pantry for decanting wine.

I think your bathroom might be the only room with one door.

You commissioned René Sergent to create this house for you. He already had a name for himself, had designed two buildings for Seligmann – your favourite dealer – and for Duveen to show their treasures in. He had form, could do restrained grandeur.

But this is a beautiful and baffling building beyond anything he has done to date. I cannot draw a plan of how it works, cannot talk myself through which room leads to which. I cannot understand how there is an extra ground floor full of useful rooms for cooking and laundry on the park side, how it is possible to enter in so many ways.

This house is like a complex mechanical box. Push this door, gently. There are spaces here, silences, one thing becoming another, one person becoming another. Doors to slip through, slip away.

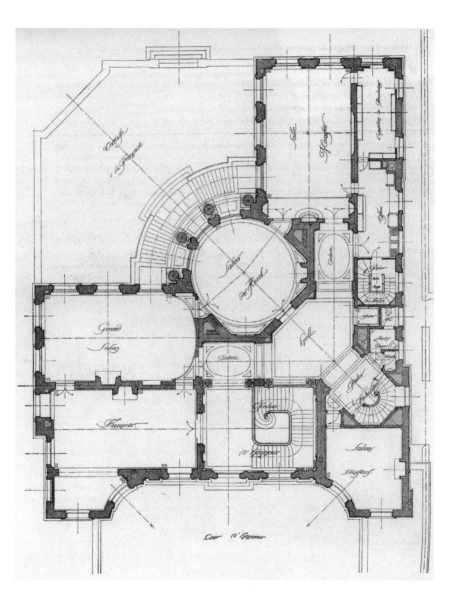

XX

Cher Monsieur,

A quick note about colour.

It is early summer so I sit on the steps leading down to the garden and this is where I start.

On colour: *vibrant.*

Achille Duchêne designs your gardens for you. They are restrained and expensive and so are the colours. Privet is planted on the boundary of the park to hide the park keepers' kiosk. In the autumn of 1913 you ask your gardeners to plant 2,400 different-coloured pansies, tufted pansies, brown wall flowers and double-flowered yellow marigolds, 'Zurich' sage and stock, large-flowered pelargoniums, four different kinds of geranium and eight varieties of begonia. This is a proper parterre: a Persian carpet to catch sight of from the windows of the *salon des Huet.*

On colour*: pastoral.*

I've moved to the *salon des Huet*. It is a gorgeous cadenced room constructed to show seven canvases by Jean-Baptiste Huet depicting the love affair of a shepherd and shepherdess.

There is a particular moment in late afternoon. It is summer and it is the country and it is warm and so the shepherdess has sat down and leans against the declivity of a bank or the stump of a tree and looks up into the branches and the sheep rest too and so

does her dog. The light is blue. There are birds that have flown from some *service du déjeuner*, a dove or two. Her dress falls open of course. The colour of the roses and her mouth. A blue ribbon round her wrist.

On colour: *unchanging.*

I'm finally in the porcelain room. The colour of porcelain stays the same. It will not fade, or suffer from damp. You can break it but you cannot destroy it. That is why the world is full of shards, fragments of colour.

XXI

Dear friend,

All those domestic tasks. The calibration of the cup of chocolate brought on the lacquer tray. The whiteness of the apron and cap. The vegetables prepared for soup, the basket of wild strawberries, cleaned. A copper basin, scoured.

This house is for Chardin. There are thirty-three of his engravings here: *Boy with a Top*, *The House of Cards*, *Saying Grace*, the *Self-Portrait*, myopic and benign. You buy them from the Goncourt Collection sale. They are in perfect order in this corridor on the first floor.

I want to sit still on one of the bergère chairs, aslant, and listen into the house. The merest percussive clink of a teaspoon against a cup. A tray of glasses being put down somewhere nearby.

Children, possibly.

Proust loves Chardin. Go to the Louvre, he writes, if you know a young man tired of the staleness of life and show him Chardin:

it is not at all the display of special gifts but the expression of the most intimate things in his life, and the deepest meaning there is in objects, it is to our life that his work appeals; as it is our life that it reaches out to touch, gradually leading our perceptions towards objects, close to the heart of things.

I look at these engravings closely for that reaching out to touch.

Chardin paints this act of moving things around, that adjustment of the world to make some shadows work harder. He puts a little porcelain on a table. The shuffle between warm teapot and slop basin and teacups, sugar bowl and milk jug, the small sounds of liquid, the glints of silver and bright linen make the porcelain seem even whiter.

Chardin takes us to still life. Your collection has only a few still lifes in it. I've found a couple of small Gobelins tapestries, *The Brioche* and *The Cream Service*, in the dining room. I peer at them. If still life is about taking time to look at the world slowly, then making a tapestry is altogether another level of slowing down.

The Cream Service has a bottle of wine and two glasses and a pastry broken into two and some porcelain *pots à crème* in a low bowl. They sit on a crumpled linen cloth on a wooden table and give still life a bad name. It is *generic*. But the brioche is next to a glass jar of slightly toxic blue-green gherkins and a bunch of pink radishes; a wine glass is upended in a glass bowl with a gilded rim. They sit on a stone shelf and here there is pleasure.

The pleasure of putting things next to each other.

And watching.

XXII

Monsieur,

Chardin could take us into conversation about porcelain – he is very good at porcelain and loves his Vincennes coffee pot – but it is rather late at night now and it's a long talk to initiate. We will get there. And I do need to talk to you about what Proust calls 'the life of still life'. I love this description as it takes me back to what you are doing here.

I know you know this. You spend forty years moving a porcelain clock and garniture of two vases and a pair of candelabra. You move pictures and tapestries, clocks and sculptures and carpets, and then you manage to find something spectacular ('a gem, a treasure') and then the ensembles have to be unpicked and tried again.

You put this *here* and set off small chords, echoes and repeats and caesuras. You put it *there* and it is just stuff, gilded and valuable but still stuff.

It is what I do in my studio. I make my porcelain vessels and I'm keeping a phrase from a poem or the shape of a fragment of music in my hands and head as I throw one after another, the balls of clay on my left, my ware boards waiting on my right. And a few hours later when they have lost some of their dampness, I trim them, searching for the balance between outer profile and

inner volume. Then firing. And glazing and firing them again. And *then* I have my moveable porcelain vessels to congregate and space, remove and replace, trying to find those moments when, if you get it right, the cadences keep going.

And the way that if you move words around you can get to a place where the images pulse with balance and power.

I'm impressed by how you have done this. The more time I spend in these rooms with you the more singular I think you are in making this whole house work together. I know you had advice from dealers on objects and Sergent is a remarkable architect, but to sustain this mood is so hard: spaces and art and light and scale and colour, rhythms and balance, energy and relaxation, intimacy and then grandeur. It is so much easier to do on a small scale and that is why vitrines work. You can reach in and move things around.

This whole place acts as a vitrine in itself where 'memory weaves, unweaves the echoes', as Octavio Paz said of Joseph Cornell. Cornell used the detritus of the world to make boxes, spaces, stage sets of affinities and discord. And he haunted the junk shops and flea markets of Flushing in Queens and you are here on the rue de Monceau with the dealers of the place Vendôme; you are both playing with memories.

You put down one object and it has assonance with another.

It makes me wonder, what was it like to live here among all these echoes?

Actually what was it like to be here at night? Cornell's sculptures are 'scarcely bigger than a shoebox, / with room in them for night and all its / light'.

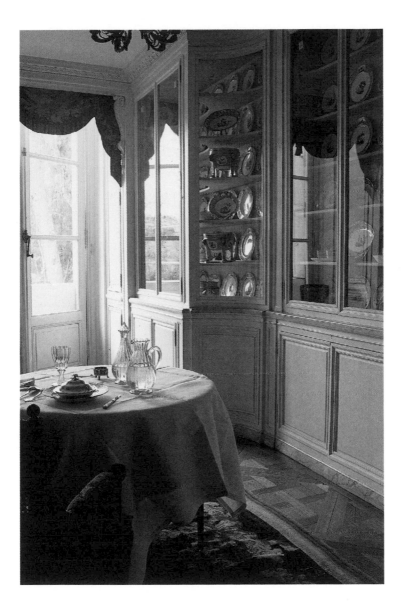

XXIII

Cher Monsieur,

You have a table set up for yourself in your porcelain room. This is refinement. The table is set with your chair facing the window onto the garden. The birds surround you. You eat alone.

Augustus the Strong commissioned a porcelain menagerie from Meissen for one of his pleasure palaces. There is quite a lot of snarling, baring of teeth. But here you are in an aviary.

The vitrines are generous, each with six shelves of Sèvres porcelain. Each vessel has the lightest of green borders – the colour of early spring – studded with an *œil-de-perdrix* pattern. The eye of a partridge – a dot of gold against the white porcelain ground circled by cobalt-blue dots. Each of the panels that hold the decoration of birds is framed in gold so that this toucan, this mistle thrush has its own little patch of the world, a rock to sit on, a bush to sing at. And then there are grey monochrome medallions of classical busts and a gilded rim because this is Sèvres and they don't know when to stop.

Not-knowing-when-to-stop is pretty much a definition of European porcelain. This porcelain, with its custard cups and salts and ice pails and *sucriers* and plates, comes from *les services aux oiseaux Buffon*. Each vessel has the name of the bird or birds written in copperplate on the base along with the Sèvres mark and year number.

I wonder if this means you could upend your *compotier ovale* to check if you had correctly identified the *tyran huppé de Cayenne* or the *faisan verdâtre de Cayenne* that both strut on this *grande corbeille ovale*. I worry – slightly – about eating a roast pheasant from a dish that shows a pheasant, this rather sultry-looking *faisan*.

But what I love about this is that all these images of birds are taken from the thousand engraved plates from Buffon's *Histoire naturelle, générale et particulière*. Careful, scholarly Buffon adumbrating the world, painstakingly marking out the differences and similarities of the whole of the natural world and all that knowledge becomes a glorious excuse for a dinner service.

The Enlightenment. Even better, the *French* Enlightenment: talk and food and porcelain and politesse and *civilité* and everything possible.

XXIV

Dear friend,

I know this isn't the most obvious house to bring children up in, and I know that there is a great rondeau of smart living with St Moritz and Biarritz and Vichy, but you do seem to have two happy children who like you and the photographs of you all in the country are lovely.

Nissim isn't a great student at the Janson (*'Élève intelligent, mais de la légèreté et de la mollesse. Pourrait faire bien mieux'*), not cut out for the family bank, but good on horseback, charming and devoted and loyal. He is closest in age to Julien Reinach who earns first place nationally in the general examinations for graduation, and just a little older than the next brother Léon who, thankfully, doesn't.

Béatrice rides beautifully. I want to know more about her life.

You plan this Paris house for these two children. It is a reaching towards something, a balancing of possibilities.

XXV

Monsieur,

You buy a *commode à rideaux* with sliding panels made by the *ébéniste* Jean-Henri Riesener. This commode is made of oak veneered with amaranth, sycamore, burr maple, bloodwood, holly, hornbeam, barberry, *bois de ferrol* – chased and gilt bronze – with a violet Breccia top. Forgive me if I simply list these materials but they are pure poetry.

Veneer is intriguing. It makes me think of the Veneerings. And the Verdurins.

Your family are written of as arrivistes, parvenus, nouveaux riches, profiteers, *nouveaux roturiers*, social climbers, vulgarians, upstarts, status seekers, mimics. As Jews aspiring to the veneer and polish of the *gratin* and failing to disguise their origins. Constantinople. Long beards and robes. Oratory at home. Etc.

The dealers have warehouses full of bits of the patrimony of France. If you go to Seligmann's, Duveen's, the showrooms of Maison Carlhian in avenue Kléber, there are rooms stripped from the Château de X or Y in some damp parkland – the topiary gone, the lakes clogged, the silver sold – chimney pieces and panelling, doors and architraves and mouldings marked up with chalk. They are stage sets. Some are reassembled in Kentucky and Ohio and in the mansions that Frick and Rockefeller and Vanderbilt

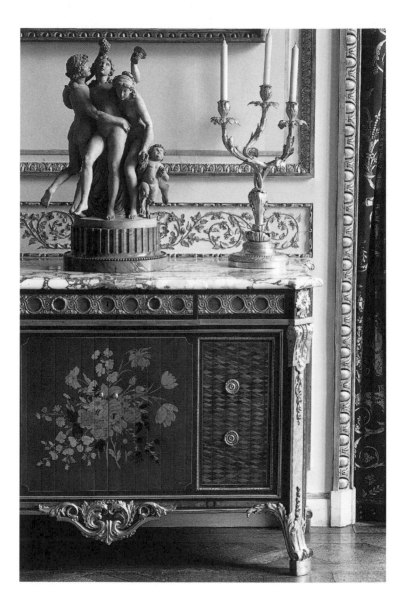

constructed on Fifth Avenue. And here in Paris, *boiseries* from the Hôtel de Mayenne have been fitted into the Cahen d'Anvers' *hôtel*.

The Count de Menou's first-floor drawing room at 11 rue Royale is transplanted to your large drawing room.

Edouard Drumont calls your father '*un chef d'eunuques abyssins*'. He excoriates my family for being Russian, ugly, ill-mannered, too forward, for supplanting French families. Both our families don't possess the inherent taste that comes from being authentically French. 'The love of bric-a-brac, of all odds and ends, or rather the Jews' passion for possession, is often carried to childishness.'

Our families are dressing up, reaching blindly into the box of costumes and props, rummaging. We are pedlars, rag-pickers, *chiffoniers*. We only act the part.

Marqueterie, the art of veneering, is a way of making one thing look entirely other. It is an art of legerdemain: a bouquet of wild flowers from a hedgerow, a couple of pheasants and a rabbit from the hunt are here, three spears and a helmet are on that bureau over there. Elements can disappear into geometric patterning. Furniture – a writing desk or the little *table chiffonnière en auge* you have in your small study – becomes a play on dimensionality, depth. You can work out how long many arts take to perfect but *marqueterie* must be one of the most complex and exhausting. The palette of the woods of the world are before you. The woods must be seasoned and then cut into dizzyingly thin slithers using bandsaws: these perfect wooden shards are almost weightless. They can then be stained or dyed or scorched or even engraved. The *ébéniste* can then construct their fantasy, an arpeggio.

I've got a photograph of you in the studio pinned up. It is during the war and Nissim must be on leave as he is a tangle of uniformed limbs in a wicker chair next to you in the garden, facing the park. The chairs are near each other and you look like you are catching up properly. You both sit the same way. I'm touched by this photo of a father and a son. You must be fifty-six and have grown a little stout. I like your boater. I look at this and think you are confident about what you love and who you love and that you just like veneer.

I like it too.

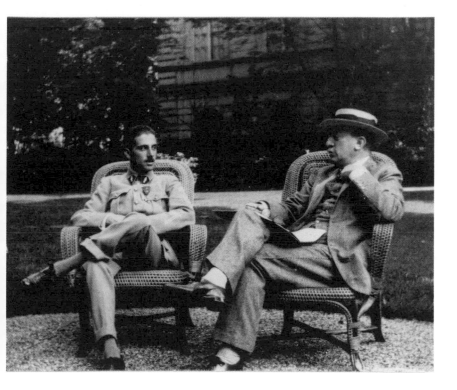

XXVI

Dear friend,

You keep the 268 letters and postcards he sent you. They are funny and warm and touching.

He writes to say he has no news.

> *Jeudi matin*
> *Rien de nouveau, mon cher Papa, le temps est beau.*
> *Je t'embrasse tendrement ainsi que Béatrice*
> *Nini*

He sends you greetings for both Yom Kippur and Easter. He writes about the misery of the trenches, about food, anxiety, friendships. He sends hugs, kisses, jokes to his sister.

He calls you *tu*. And he signs off his letters *Mille et mille tendresses, Je t'embrasse tendrement, Je t'embrasse de tout cœur.*

He is twenty-four.

He has courage. He volunteers immediately, fervent, and is at the front where this is tested with the dreadful attrition of friends and comrades dying in the cold, cloacal landscape. A friend is killed next to him. His uncle Charles is an observer in one of the air squadrons and Nissim decides to apply to join, his application is approved on 11 January 1916 and his life changes again.

'I am sure that if you got into a plane, you would love it. It is a marvellous sensation and what is curious is the great impression of security one feels.' He writes of the cold and the rain and the snow, but above all of the exhaustion of these flights. He makes it sound a bit like a hard day at the hounds. His cadre are a band of young men, a third of them from cavalry regiments.

'I am starting to be rather popular,' he writes on 16 April 1916 and he is. He is mentioned five times in dispatches, is promoted. At Verdun he flies reconnaissance flights and combat missions, but his expertise becomes taking photographs of the enemy positions. This is even more dangerous. Four thousand feet is the optimum height, but you can go as low as 2,500, and at these heights you are vulnerable to weather, to enemy fire. You also need to fly over communication trenches and front-line trenches and gun emplacements.

These photographs are beautiful. It is a terrible beauty.

In the archives they are rolled up; when unrolled they stretch across a long table: two metres of a deep blue, white inscriptions and notations of location. They show a scarred world. It is a body, lined. From up here villages become a scratch, a river becomes a lesion.

'We are constantly on the move,' he writes during the Nivelle offensive in the spring of 1917. The weather is atrocious as they fly mission after mission. Below them are 135,000 French casualties in three weeks. There is the terrible anniversary of the battle of Verdun, the heroism of Pétain. He thanks his father for the wonderful chocolate. The weather has changed and it is hot: could he search for some summer clothes?

On 5 September 1917, at the end of the morning, a Dorand aeroplane leaves the base at Villers-les-Nancy for a new mission with Nissim as pilot and Lucien Desessard photographer and gunner. After two hours they have not returned. Friends write to you to say they know of prisoners in German camps, to wish you courage.

I hold the letter Proust writes to you from 102 boulevard Haussmann in these days of uncertainty.

I learn with deep sadness that you are tormented by the fate of your son. I don't even know if my name will mean anything to you, I used to have dinner with you at Mme Cahens, and more recently even though an age ago, you once came to dinner with me with my dear and much-loved Charles Ephrussi. All these memories are very old. They were enough, however, for me to feel the piercing anguish when I learned that you were without news of your son … I wish that there is happy news for you. I don't know your son but have often heard of him.

And then there is more news of the final engagement at 3,000 metres with an enemy aeroplane, the sight of their damaged plane, flames, a spiral towards enemy lines. No knowledge of parachutes. And then there is the confirmation of Nissim's death three weeks later. He has been buried with military honours in a German cemetery in Avricourt.

There is the sheaf of letters from family, from friends who write beautifully and tenderly of Nini. There is a memorial service on the 12 October at the Grand Synagogue. Nissim is awarded a posthumous *Légion d'honneur*.

'This catastrophe has broken me and changed all my plans.'

XXVII

Friend,

So how do you honour the dead? You put a photograph on your dressing table. You honour your word.

Your house, his house, changes.

Nissim's rooms become a shrine.

His study becomes a memorial room: *une chambre du souvenir*. It has restrained panelling, a herringbone floor. The steel-and-gilt bed, the desk with its quiet mounts, the green morocco armchair are all clubbable, male. The candelabra on the marble mantelpiece come from a royal prince which feels appropriate. There are hunting pictures, a meet at dawn. You hang the portrait of your father Nissim by Carolus-Duran above your son Nissim's bed.

On 20 January 1924 you write in your will that you want 'the portrait of my father by Carolus-Duran and all the photographs of my son which you find in diverse places in the house to stay always in those actual places'. Here is your boy smiling on the esplanade at Deauville on your desk in the blue drawing room, here in the large study are two photographs of him in uniform. And another picture sits in your bedroom.

I think about my great-uncle Iggie and his beloved partner, my uncle Jiro. They met in 1950. They were together for forty-four years until Iggie died in 1994. I came out for his funeral in the

beautiful temple in Tokyo, said Kaddish for him. They had bought a grave together years before. *Ephrussi Sugiyama* was inscribed on the headstone.

When Jiro died twenty-three years later in 2017 I came to the funeral, I stayed in Iggie's old apartment.

The apartments were next door to each other with a door between them. Nothing had changed in all those years. The furniture and the few restituted pictures from Vienna and the Chinese porcelain and the weathered bronze sitting Buddha where they had always been. The pots that I had made in Japan as a teenager and given him were still there, earnest and rather heavy among the Chinese celadons. The great vitrine in the drawing room held the hundred netsuke that Jiro had wanted to keep while he was alive: I was to take them and reunite them with the others in London. The wardrobes were empty. The apartment was still cleaned each week but the dust on the tops of the books was thick, mantling the Proust, the children's books from a childhood on the Ringstrasse a century before, the runs of detective stories that he loved. Iggie's pens lay next to the blotter. The photograph of these two men in their dinner jackets arm in arm stood to the left, a photograph of my grandmother Elisabeth in Paris, scholarly and smiling, on the right.

And I open the drawer of the desk to find some paper. I need to write my memorial speech for this afternoon's funeral at the temple. I want to talk about families, about being Japanese and Jewish, about two men from Vienna and Shikoku and how you belong to a place and belong to each other. And in this drawer are his mother Emmy's fans from the opera, from balls in

fin-de-siècle Vienna made from ivory and lace, painted with pastoral scenes, shepherdesses from some Fragonard idyll. They are wrapped in tissue paper, encased in satin boxes from Paris shopping trips at the end of the nineteenth century. Kept near to hand, kept private. How had they survived? There is no one left to ask.

What is it to leave something, leave someone? You want to come in and sit and be near. The space holds the chance that they have not gone.

Your house in the rue de Monceau stays the same.

The apartment at 610 Takanawa Park Mansions stays the same. They wait.

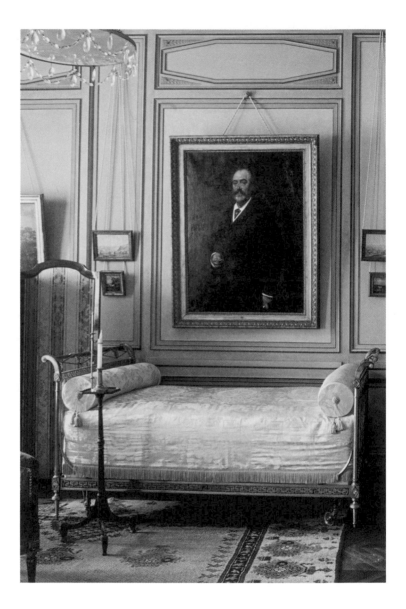

XXVIII

Cher Monsieur,

Nissim is Hebrew for miracle. You name your son for your father.

XXIX

Monsieur,

In haste.

I've been reading more of Théodore Reinach. And I just found this and wanted to share it. It is 1917 during the dreadful autumn in which you lost Nissim. Théodore's oldest son Julien is at the front and has won the *Croix de Guerre*. His nephew Adolphe Reinach has been killed in the first month of the war and by September 200,000 French soldiers have died. The call in the papers and on the streets is for the *union sacrée* – the putting aside of all differences in the cause of France, attacked as in 1871 by Germany.

Reinach addresses the Union libérale israélite, the association he has founded to advance ideas of assimilation, and his topic is *ce que nous sommes*, what we are.

The Union, he says,

promises to destroy all the barriers, to eliminate all the misunderstandings that could separate the Israelite and the French patriot of the twentieth century, to reconcile definitively and strengthen one by the other the touching attachment which connects us to the great and painful past of Israel and the no less filial attachment to this mutilated homeland of 1871.

He returns to definitions, puts them aside. There is a future full of hope, he says, stirringly.

There are two homelands but no barriers. The fissures of Dreyfus must be put aside. We know *ce que nous sommes.*

XXX

Dear friend,

You spend years waiting. 'Perhaps,' writes Walter Benjamin,

the most deeply hidden motive of the person who collects can be described this way: he takes up the struggle against dispersion. Right from the start, the great collector is struck by the confusion, by the scatter, in which the things of the world are found.

Dispersion, confusion and scatter nail what happens to French art of the eighteenth century.

There is the ransacking of the Revolution, the taking-back of what is rightly ours, that incandescent righteousness, and then Napoleon and then the Empire, and this means that 'the things of the world' are to be found in museums and dealers' showrooms on rue Royale and Bond Street and in the hands of Seligmann and in provincial auction houses.

Le garde-meuble, the Royal Furniture Repository, records every single object in the palaces, numbers it, but these labels go astray, are forged. It becomes a great game, this piecing back together again of the art of these royal rooms. Charles writes of 'almost unobtainable objects' and the phrase hangs delicately in the air.

It takes you thirty years to reunite the two *commodes à l'anglaise* that you place in the *salon des Huet*.

The dealers know you. Their letters with their *enc. for your kind consideration* packet of photographs of a pair of silvered bronze console tables that are 'believed to have been given by Louis XVI to someone for something' come in most days. On 30 March 1935 Jean Seligmann offers you 'these vases, whose mounts are attributed to Gouthière ... are believed to have been in Marie-Antoinette's boudoir at Trianon'.

Proust understands you:

And I had already lived long enough so that, for more than one of the human beings with whom I had come into contact, I found in antipodal regions of my past memories another being to complete the picture ... In much the same way, when an art lover is shown a panel of an altar screen, he remembers in what church, museum, and private collection the other panels are dispersed (likewise, he finally succeeds, by following the catalogues of art sales or frequenting antique shops, in finding the mate to the object he possesses and thereby completing the pair, and so can reconstruct in his mind the predella and the entire altar).

And I know you too. To want to make something complete, to need to bring things back together, you have to know what separation feels like, feel dispersion.

You start to make this house and then your son dies. The house changes. It is for him to come back to, it becomes something to give to this mutilated homeland.

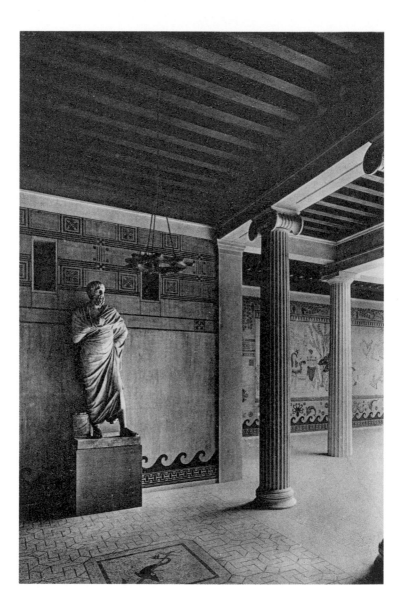

XXXI

Monsieur,

Your daughter Béatrice marries Léon Reinach on 10 March 1919 in the temple and this is a truly happy day. You write that your mind is at ease.

The announcement is published in *Le Figaro* on the next day:

Hier a été célébré, au temple de la rue Buffault, le marriage de M. Léon Edouard Reinach, fils de M. Théodore Reinach, membre de l'Institut, officier de la L.H. avec Mlle Louise Béatrice de Camondo, fille du Cte Moïse de Camondo, le collectionneur et sportsman connu.

Léon could not be more suitable: it is another dynastic alliance.

Léon's mother is Fanny, the daughter of Betty Ephrussi. Fanny has three childless Parisian uncles and so has become heir to one of the greatest fortunes in Europe. Théodore and Fanny have brought up their four sons in Paris and in the Château Reinach in La Motte-Servolex, in the Savoie region, remodelled in Louis XIII style with the letter *R* pretty conspicuous.

After his marriage Théodore is appointed the editor of *Gazette des beaux-arts* which Charles Ephrussi now owns. They become close friends and I am touched to find that he helps carry Charles's coffin in the cortège at his funeral in 1905.

And while they are getting their chateau so wrong, Fanny and Théodore start work on the Villa Kérylos at Beaulieu-sur-Mer, between Nice and Monaco. The site is astounding. It is built out on a promontory with the sea on three sides, a white Greek villa framed exactingly around an open peristyle courtyard of Ionic columns. There are mosaics in the floors with dolphins and octopi and delicate frescoes of branching trees and birds, and there is marble panelling, and leaded windows that open to the terraces and gardens and the sea. It takes five years to build and seven million francs from Fanny's dowry. Her bedroom has a balcony so that you can step out and look at the drama below. In her mosaiced bathroom there is a stucco frieze showing a lady at her toilette with attendants. The taps in her shower have playful Greek inscriptions to indicate the water pressure.

Kérylos means kingfisher. It is a beautiful name for this place dazzling against the sea.

It is cool in summer and freezing in winter, the Greek furniture looks supremely uncomfortable and the marble baths must take hours to fill, but this is poetry, a beautiful staging of what it is to live here on the edge of a Homeric sea and think of Ovid and Sophocles and what it is to be part of culture unfolding in this new century where 'moral assimilation' will flourish between the Jewish and the French.

And Villa Kérylos is a temple. Writers and politicians and scholars, musicians and artists, the odd exiled king and lots of Reinach, Ephrussi and Camondo summer here. And there are cousins nearby. Twenty minutes' walk away, Béatrice Rothschild, now married to Maurice Ephrussi, builds a pink palace, the Villa

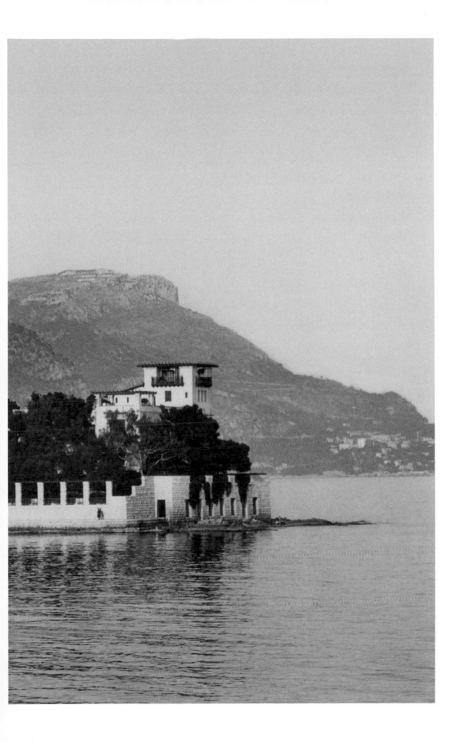

Ephrussi-Rothschild, and fills the house with French furniture and Sèvres porcelain. The Villa has nine different gardens, Mexican, Japanese, Florentine, and a 'lapidary garden' filled with architectural fragments bought from ruined monasteries and palaces. Her gardeners are dressed like sailors, with red pompoms on their berets in honour of the villa being like a yacht at sea. Which does take it a little far.

Léon Reinach is a young man of great culture, a serious musician who has studied at the Paris Conservatoire and a lover of poetry, and with no need to do anything at all. He is absurdly rich, even by Camondo standards.

Léon and Beatrice are the same age. They have known each other all their lives. They both mourn Nissim, I think, and that is a powerful bond in any circumstance.

There is a nice photograph of him, legs crossed, deep in a chair reading. He is smoking and there is a piece of paper stuck into the book. He is taking notes, like a Reinach.

The young couple begin their married life in 63 rue de Monceau.

XXXII

Dear friend,

There is a review that I'm sure you've seen.

The Sonata for piano and violin by M. Léon Reinach, strongly defended by Mlles Yvonne Lefébure and Lydie Demirgian, is especially valuable for the warmth of the first two movements, although they are still tainted with influences from Franck and Fauré.

The reviewer is right. There is a recent recording and I've been carefully listening to it.

It must have been difficult for Léon, I think, with Théodore as his father, seemingly engaged everywhere.

And involved with music too. Théodore campaigned to introduce new music to synagogues as part of his attempt to align French and Jewish culture. I have just bought – online late at night from an antiquarian bookseller, for too much money – Théodore Reinach's *Un nouvel hymne à Apollon*: a signed copy of his transcription of a Greek stone tablet from the third century BC and his interpretation of it into contemporary musical notation. The footnotes are in three languages, and the musicologist friend to whom he sent it has added his own pencil annotations to this. It could not be more Delphic and I'm baffled by my

purchase but pleased to overhear this conversation. I find that Théodore asked Fauré to do a version of it and played it for his friends.

I am not sure where that leaves Léon to try out his own path as a composer.

Possibly sitting, long-limbed, in a chair with a book, ignoring the photographer.

XXXIII

Monsieur,

My grandmother Elisabeth Ephrussi visits Léon and Béatrice in 1922. They are cousins – second cousins, I think, on one side – and lots of close family ties on the other. I can draw a family tree, possibly, but it would be a spider's web. Cousins intermarry, of course, so that there are whole branches of hyphenated families. But how do you note that Louise Cahen d'Anvers, Béatrice's grandmother, was also Charles Ephrussi's lover for fifteen years? A dotted line? Something in red?

Elisabeth has come to Paris full of ardour. She is in correspondence with Rilke, has sent him letters and drafts of poems. He has sent her some parts of the *Sonnets to Orpheus* and is counselling her about her plans. Should she continue her academic studies or write? They are different paths and incompatible, he writes to her. They might meet here. Proust has just died and Paris will never be the same, writes Rilke. She travels from Vienna to see Rodin's sculpture; meet her hero; be in Paris by herself.

She is very well brought up and does the rounds. She visits 63 rue de Monceau. Béatrice and Léon and their two-year-old daughter, Fanny. Béatrice is pregnant with Bertrand, born in the spring.

And Elisabeth moves to Paris in 1928. After her marriage to my grandfather Henk – a dashing Dutchman, monocled and violin-

playing and a little shaky financially – the de Waals live in the rue Spontini in the *seizième*, with brand-new Ruhlmann furniture and Van Gogh reproductions and (briefly) Schiele paintings. There are some photographs of their apartment and it has great style. Nothing is old. Nothing is inherited. And Elisabeth writes journalism and fiction and later on they have two boys, my father, Victor, and then my uncle, Constant.

I'm not sure what Elisabeth and Béatrice have in common at first sight. My grandmother does not like horses or shoot or hunt. She has a doctorate in law and writes poetry and discusses opaque philosophical matters with economists. Béatrice lives for horses, cuts a dash. Elisabeth's sense of fashion, according to my great-uncle Iggie, was errant, risible. 'She simply had no taste at all,' he told me fondly, sitting in his apartment in Tokyo, remembering his sister in Vienna.

And then I think that they both have fathers who are the same age, have come from elsewhere.

You, Monsieur le Comte, were born in 1860 in Constantinople, became Italian and are now as French as can be. And Parisian to boot.

Elisabeth's father, Viktor Ephrussi, was born in 1860 in Odessa, became a baron of the Austro-Hungarian Empire. And Viennese.

And that both these young cousins have that fracture of unhappy mothers – younger, dynamic, beautiful women, married dynastically, settling some familial obligation. Mothers who either tried to – my great-grandmother Emmy – or did – Irène – get away.

Both were brought up in museums. The Palais Ephrussi with its family cipher inlaid in marble as you crossed the threshold, the

Hôtel Camondo a place of reverence for a grandfather and a lost brother. Just think what it is to come back to a house with your name on, that suffocation.

And seeing a photograph of Béatrice clear a ridiculously high fence, and reading Elisabeth's exhilarated essay on modern thought and the architecture of skyscrapers, makes me think that both these young women, both in their twenties, are trying to find out what escape might mean.

XXXIV

Can I talk to you about the children's bedrooms, Monsieur?

Nissim's bedroom is a shrine. When Béatrice and Léon and their two small children move out to their smart apartment in Neuilly in 1923, you turn Fanny and Bertrand's bedroom into a new sitting room. And actually it is the most comfortable room in the house I think with its windows on two sides, looking out onto the park and over to Cernuschi's house, now a museum showing his collections of Asian art. You feel you are in the trees here. And it is informal, or as informal as you allow yourself to be: a sofa that you could stretch out on and a desk that you could actually write at with proper lamps. And a *duchesse brisée* – an armchair with an extended footstool – that looks like a chance to read books in the afternoon. I like the name and I want one.

Somehow this room escapes the memorialising.

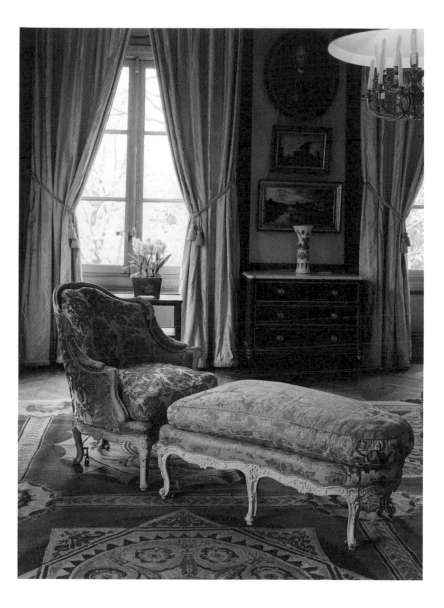

XXXV

As you so evidently understand the archival principle – check, check again, record – I need to tell you about my visit to see my father.

He is wearing a straw hat and sitting outside his red door in the little community of almshouses where he lives. He is ninety-one. I take him a couple of books – the speeches of President Steinmeier and the new novel by Hilary Mantel – and some goat's cheese and chocolate cake. We have coffee. It's a good moment to talk to him as he has given up on writing his memoirs, they don't seem so significant to him now. And he's busy. There is the local asylum and refugee centre with which he's involved. And time keeps slipping anyway. People from his childhood are more real, more present: he talks to them. I ask him about Paris in the early 1930s.

He remembers the rue Spontini apartment and the cook and maids and a beloved nanny who came from the Altsee in Austria. They were there for five years until one of his father's financial disasters made them move. The apartment was big enough to pedal his toy car down the corridor, at speed. Paris was full of cousins, he says, elderly ladies in grand rooms, papery cheeks to be kissed. He played in the Bois de Boulogne and was taken to see the Impressionist paintings in the Jeu de Paume, *coll. Ephrussi*.

And he doesn't remember the Reinachs. An apartment in Neuilly? A musician? A horse-riding cousin, rather well dressed? No.

But then he remembers that his mother was to inherit all the fortune of the last Paris Ephrussi uncle. But that uncle died in 1915 while France was at war with Austria–Hungary. So the Viennese cousins became the 'enemy' and Léon inherited their collection of Impressionist paintings and their Paris houses too.

He does have all the love letters between his parents written in the 1920s. There are funny and tender and so revealing and are in Dutch.

Might they be of interest?

My father asks if I can I help him with his application for Austrian citizenship. The law has just changed to allow Holocaust-era families to apply for the citizenship which was denied them, taken away. My father is named after his grandfather Viktor, who loved him. Viktor was born in Odessa, grew up in Vienna and died stateless in England.

This application is also for him.

XXXVI

Cher Monsieur,

I think there is a tendency to imagine you alone in this house. 'Happiness of the collector, happiness of the solitary: tête-à-tête with things,' wrote Walter Benjamin with some kindness to the condition in one of his terse notes in *The Arcades Project*.

And I know you must have been alone as you are long divorced and your son Nissim dies in the First World War and your daughter Béatrice marries and moves away.

This is a house full of people. There are fourteen servants – butler, under-butler, a couple of manservants, footmen, chef, chef's assistant, odd-job man, laundry maid, gardener, a stoker for the boiler, a couple of mechanics for the cars – but aloneness and living with servants isn't incompatible I believe. And you entertain, of course.

As I walk through these rooms with their cabinets and bronzes and marble sculptures and tapestries and gilded candelabra, I think of all those craftsmen talking to each other.

In Diderot's *Encyclopédie*, there are definitions for the crafts of *serrurier, ciseleur, orfèvre, graveur, arquebusier, bijoutier, metteur-en-œuvre, damasquineur*.

Your house is full of noises.

XXXVII

So, Monsieur,

I'm in your library. I love this room. It is circular which is unusual for a library and must have been testing for the joiners who made the bookcases. The panelling is restrained: you've toned down the gold, and the tapestry of a man struggling to do up a valise to put on a horse is pretty much as straightforward as anything gets in the house. And the chairs look comfortable. I've noticed that you have your father's copy of *Histoire de la poésie des Hébreux* among all the classics. I'm glad. And I'm pleased to see that you have Charles's book on Dürer, written in his study up the rue de Monceau all those decades ago. I'm convinced that quite a lot of collectors ordered in their libraries by the yard along with the draperies, but you love books.

I've been fretting about melancholy. I was talking about your house to a friend and she described the atmosphere as melancholic, and this felt a bit pat, not quite right. Actually I was riled as I am getting proprietorial about your house if I'm honest.

Fretting took me back to Dürer's engraving of Melancolia. Melancholy rests her head on a closed fist. She is inert. Around her are strewn tools, objects of discovery, a crucible, tongs, a hammer and nails, and a saw and a plane and pincers: everything

should be possible and yet nothing is. A ladder is blocked by a heavy planed piece of stone. The bell is still, the greyhound at her feet is still. The world is caught. She could reach out into this archive of things and thoughts and possibilities but she is unwilling, unable.

Dürer says that with 'too much exertion we fall under the hand of melancholy'. I look at her hands carefully.

Benjamin wrote on melancholy, said that he 'came into the world under the sign of Saturn – the star of the slowest revolution, the planet of detours and delays'. He is the poet of delay, writing of flâneurs, determinedly ambulant. He gets lost easily in cities and in texts. He cannot finish his book on Paris. He compared himself to a rag-picker, one eye in the gutter to find the rejected and overlooked: rag-pickers are not fast. There is some pleasure he says in this, an art to getting lost. He calls it *Irrkunst*.

I think you are lost.

There is no sign of it. You make this place for your father and for your son, and you do it impeccably. It is a site of mourning, *lieu de mémoire*. The world of mourning concludes only after a reasonable amount of time, says Freud in his essay 'Mourning and Melancholia'. Mourning has its rituals that allow us a particular space to return to loss: you mark out an absence. And that is healthy as you can then move on. You, Monsieur, say Kaddish. You bring Nissim back to the cemetery, you make your will, the gift. You mourn. This is to be the Musée Nissim de Camondo: your act of mourning.

You do a very good job of mourning, Monsieur, and I commend you.

But melancholia is the extraordinary prolongation, the refusal to give up. It takes you off into detours and delays. It makes me think of Proust and his page proofs: paragraphs inserted, phrases, the fear of ending it. And I think you cannot give up your loss, cannot lose loss, cannot stop moving objects, adding, rag-picking.

I think this is truly melancholic. Not because of what happened next. Sadness isn't melancholic.

I can't stop either.

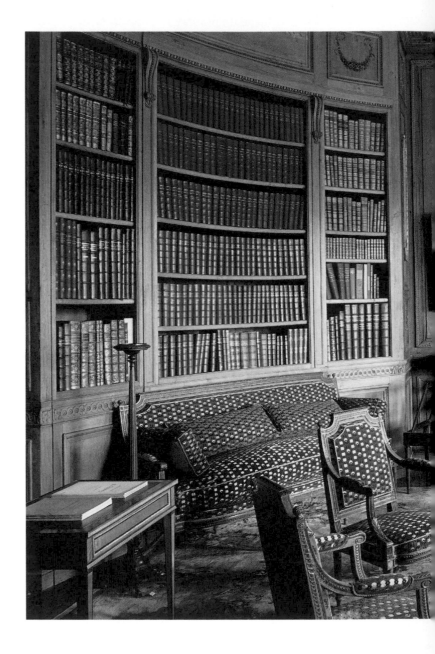

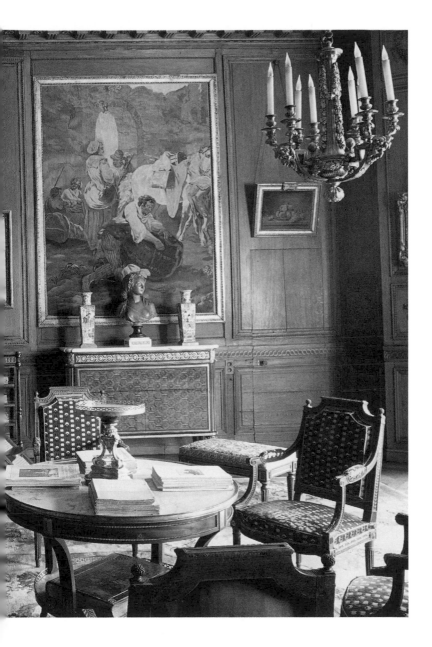

XXXVIII

Friend,

I'm not sure if children still name the place that they are in, listing on the cover of an exercise book the cinematic pullback from this desk to this schoolroom to school to street to town to county to country to continent to world to universe and out into unimaginable space, placing themselves, settling themselves and their sense of self. *I belong here.*

I've been thinking about you sitting at a desk and where you belong.

You *belong* to – deep breath –

inter alia

Société des Artistes et Amis de l'Opéra

Société des Amis de la Bibliothèque d'Art et d'Archéologie de l'Université de Paris

Société des Amis de la Bibliothèque Nationale

Société des Amis du Musée Cernuschi

Société des Amis de Sèvres

Société des Amis du Louvre

Société des Amis du Musée de la Tour

Cercle de l'Union Artistique

Commission des Arts Plastiques

Conseil d'adminstration de la manufacture des Gobelins
Maison d'art (Fondation Baronne Hannah Charlotte de Rothschild)
Chambre syndicale de la curiosité et des Beaux-Arts
Congrès International des Bibliothécaires et Bibliophiles (which is the
one that sounds most intriguing).

You are a donor member of the Société des Amis de l'Enseignement
par les Musées, a founder member of the Société des Musées de
Strasbourg, an active member of Société Française d'Archeologie,
Société Française des Amis de la Médaille, a member-benefactor
of the Société des Amis du Mobilier National, the Société
d'Iconographie Parisienne.

And, of course, there is the Club des Cent for gastronomy
which must take up quite a bit of time, and the clubs for
automobiles and the Jockey Club and the Hunt and I'm sure a
dozen more. Not to mention those endless commissions that are
got up to celebrate this (a Byzantine art exhibition), commemorate
that (Houdon, Manet, Goncourts, Hubert Robert), or preserve
some fragile part of French patrimony. You help to buy Courbet's
The Painter's Studio in 1920, which is a good move, and support
a campaign to buy Degas prints. Most of these need your name
and a cheque. Actually, all of them need the cheque.

Joseph Roth is here in Paris, in exile from Nazi Germany, writing
essays for the newspapers to support himself, and talks of how a
Jew becomes French: 'He may even become a French patriot.' You
could not be more generous. You could not be more Parisian. Your
private life and public life are in alignment. You are a French
patriot.

If you belong to enough things does that make you belong here, sitting on this splendid carved and gilded chair in

le petit bureau
no 63 rue de Monceau
VIII^e arrondissement
Paris
La France
L'Europe
Le Monde
L'Univers?

It is a question, Monsieur le Comte.

XXXIX

Monsieur,

Today is 22 May. I'm in London in my studio. I walked my dog here from our house. It takes twenty minutes or so, cutting across a little park and ending up on the edge of an industrial estate. In my yard there is a steel fabricator, a jewellery retailer and a company that makes signs for West End theatres and cinemas.

You might approve of Isla, my dog. She is a Grand Basset Griffon Vendéen, a shaggy French scent hound and I know you love hunting and shooting on your country estate. She bays in the evening hopefully. We have rather a lot of foxes in south London.

I'm being specific about the day as I have a record of the dinner you gave on 22 May 1935 and this gives me a chance to talk to you about food.

Œufs pochés Princesse
Bars glacés à la gelée sauce verte
Jambons d'York en croûtes sauce Madère
Nouilles à l'Alsacienne
Barons de Pauillac rôtis
Salade de romaine
Petits pois à la Française
Chester cakes

Pailettes au parmesan
Glace Nélusko
Patisserie

There are the annual luncheons you give, one for the curators
from the Louvre and one from the Musée des Arts Décoratifs.
The Club des Cent has its luncheons and dinners and excursions
and you are diligent in noting down details of meals at hotels and
restaurants. You have a famous cellar.

I've spent most of this morning looking up what all this is and
now I know that *Chester cake* is a double-crusted pie with softened
cake crumb and fruit and spices, made up of stale cake. And that
Glace Nélusko is '*une bombe glacée au chocolat et au praline relevé
de curaçao*'. I'm sure this must have been presented at some dinner
in Proust but that is taking research too far.

And all this is glorious stuff and I know heaven is eating caviar
to the sound of trumpets, but I want to ask about the date jam
sent from Cairo and about buying *boutargue* from Martigues. It
is grey mullet roe that has been pressed, dried, salted and spiced.

It is the taste of Constantinople, childhood, that breeze.

XL

Monsieur le Comte,

I've been thinking more about all the palaver with the great luncheons and dinners you give. The food ascending in the dumb waiter to the butlery where there is a plate-warmer and space to check the *mise en scène* of each dish before a door in the panelling opens into the dining room. There is the contrast with you sitting in your room of porcelain by yourself.

And as I have had to reread Proust because of you I've been thinking of the way that food elides into art and out again. I've been coveting the small painting of a lemon on a dulled silver dish that your cousin Isaac bought from Manet. It is pretty much the only lemon you will ever need. The tarnish makes me taste tarnished silver, the hit of acidity. And then that makes me think of the bunch of asparagus that Charles bought the same year from Manet, off the easel. The price was eight hundred francs and Charles, open-hearted and open-handed, sent a thousand. And then four days later a small canvas with a solitary asparagus spear is delivered to the rue de Monceau, a scribbled M in the top right-hand corner with Manet's note, 'this one has slipped from the bundle'.

There it is, discussed at dinner with the Duc and Duchesse de Guermantes over the *asperges sauce mousseline*:

I know of course that they're merely sketches, but still, I don't feel myself that he puts enough work into them. Swann had the nerve to make us buy *A Bundle of Asparagus*. In fact it was in the house for several days. There was nothing else in the picture, just like the ones you are eating now. But I must say I refused to swallow M. Elstir's asparagus. He wanted three hundred francs for them. Three hundred francs for a bundle of asparagus! A louis, that's as much as they are worth, even early in the season.

Food becomes still life becomes a book becomes an archive. And a dinner becomes a story. The longer I spend in these rooms, these archives, the more careful I think you are about these elisions. These plates on your dining table cite Buffon. You have just bought a service of silver made by Jacques-Nicolas Roettiers for Catherine the Great. It has been sold by the Soviet government who need money for everything and have a lot of silver. And the silver is here to talk – with charm – to the Sèvres porcelain.

You want to have Voltaire at this dinner table.

I've finally understood what this house is about, this extraordinary attempt to make one space after another work without discomfort or falsity. You want to make a perfect stage set for conversation, enlightenment, for that moment when French culture was at its most refined, most searching.

Walter Benjamin, in exile, struggling to finish his book on Paris in the Bibliothèque Nationale, shuffling his index cards with their minute indexical quotations on Baudelaire, shopping, Haussmann, collectors, writes that 'this work has yet to develop to the highest degree the art of citing without quotation marks'.

That is what your Musée Nissim de Camondo is becoming for you, a place with no quotation marks, no vitrines, no ropes or guidebooks. You have made a space to talk to the dead, to welcome them in.

XLI

Cher Monsieur,

As you have a number of books of essays in your library, I thought I'd suggest some topics to discuss together in the manner of Montaigne:

On why you keep carbon copies of everything.

On placement at dinner parties and on the placement of furniture in the house and the connection between these two actions.

On being partly deaf.

On being partly blind.

On bed. How do you sleep in a bed that size?

On Kaddish.

On the sounds of the kitchen.

On being exigent.

On the papers. *Le Figaro* comes daily, *Le Gaulois* comes daily, *L'Illustration* comes monthly, *La Revue de l'art* comes monthly, *Gazette des beaux-arts* comes monthly.

On mirrors. On glass. On surfaces that reflect and surfaces that don't.

On the bacchante. Really?

On smell. On camomile and Montrachet.

On the sounds of children in the house.

On the sounds of silver on porcelain.

On the sounds of the gardener clipping the box hedges.

On those lunches you gave Louvre and Marsan. How long does a luncheon last?

On sitting for portraits. Carolus-Duran and Boldoni and Renoir. How do you choose? What is it like to see a portrait of yourself at the Salon?

On family graves.

On how you greet people. Visitors to the house can arrive by horse, by car or on foot. Discuss.

On what the dealers are trying to sell you now. There is an envelope from X in London with six photographs. They have the pleasure in inviting you to take the opportunity of reserving these works. Highly significant exempla of the work of Y from *le garde-meuble de la reine*. Let me beg of you that you take this. It ought to strike the perfect note alongside your other treasures.

On comfort in your museum. 'Since visitors usually keep their coats on, only this entrance should be used, especially as it is more economical.'

On enlightenment. The liberation of the Jews. The abolition of slavery.

On provenance in objects and on provenance in family. Family trees as inventories.

On trees. On privet.

All for now. I'll wait to hear which we should attempt. *Essais* are a start of conversation, contingent and digressive. You cannot be completely sure where they will lead you.

Well, a final one.

'The shape of my library is round, the only flat side being the part needed for my table and chair; and curving round me it presents at a glance all my books ...' writes Montaigne in his essay 'Of Three Kinds of Association'.

On having round libraries: Michel Eyquem de Montaigne and Moïse de Camondo.

XLII

So, Monsieur, I want to write about this not lending and not changing anything or adding to the collection. It is there in your will. I am very pleased that the one exception is for the *Gazette des beaux-arts* to be added to the dozens of volumes sitting on those curved shelves in the library. And that you stipulate they should be bound in red morocco. But it might be taken as perverse or arrogant to give a collection to the nation and then insist that it cannot change. It certainly causes problems for the generations of curators who tend this place, not being able to lend treasures or borrow them. You would have known the Wallace Collection in London which was set up in the same way with an Act of Parliament, no less. And there is a beautiful house in Cambridge called Kettle's Yard where the collector made the same stipulation when he left. Flowers in an earthenware jug on a bench renewed, *just so*, the spiral of pebbles, an empty picture frame checked for alignment every day.

This riles some people, but I understand the impetus to keep things still, to still the world. Enough. I'm here, I've stopped moving, wandering, and so have these things around me. I belong *here*.

I'm caught out by this, to be honest.

I love the feeling of objects in transit, that pulse that I wrote to you about, the contingency of something being here, no *there*.

But when I started making installations, placings of pots onto shelves or cabinets or vitrines, high up held in space, or sometimes below ground, I found I loved that feeling of someone having just left, the objects still warm from handling.

If the installation works there is a roominess in it, the sort of shrug of something being safe to let go, leave. It isn't a need for fixity, a dogma of not moving, but the apprehension that, just briefly, the world has paused. The velocity of things, bundling from place to place, hand to hand, from my kiln to dealer to collection, can just be slowed.

It is a breath-turn, a caesura.

So I think what you are doing here is a way of keeping things safe. I think you know what you are doing is difficult and perverse. I think you know what dispersion means in your heart. You know that the world is entropic.

And I think that you see this diaspora happening and want this staying still and this moment of the turn of the breath.

You are taking a bet on the future.

XLIII

Or perhaps not, Monsieur.

Sorry to come straight back to you, especially after such a moving ending, but I couldn't sleep last night as I've been worrying about the gift and gift-giving; who is giving and who is receiving.

Nissim gave his life for France and the gift from France is that of emancipation, equality for the Jews, a welcome of sorts and tolerance, a place to settle, a hill of friends and cousins, conversation among equals.

I have my grandmother Elisabeth's copy of Théodore Reinach's *Histoire des Israélites depuis l'époque de leur dispersion jusqu'à nos jours* which ends, passionately, with the lines that 'Judaism thus owes the breaking of its age-old chains to the Revolution ... we can say that any Jew today with memory and heart has a second fatherland, his oral fatherland, the France of 1791', that moment when Jews are given full citizenship.

And you are giving back to France the most perfect house filled with the art of the most perfect moment in French culture, a reflection of France. The gift binds person and place, nation, family.

Gifts bind you to the receiver, they are sticky. They leave a residue. I know. I was given a collection that started on this golden hill.

Gifts can be retracted but they can't be forgotten.

XLIV

Actually, can you *give* someone emancipation?

I've just remembered that there is a bust of a black woman in the dining room, a bronze cast after a model by Houdon with an inscription running round the base:

RENDUE À LA LIBERTÉ ET À L'ÉGALITÉ PAR LA CONVENTION
NATIONALE LE 16 PLUVIOSE DEUXIÈME DE LA RÉPUBLIQUE
FRANÇAISE UNE ET INDIVISIBLE

Slavery was abolished in France on 4 February 1794. This bust recalls a fountain that stood in the gardens that preceded the Parc Monceau, which showed a black lead model of a slave pouring water from a golden ewer over her white marble mistress. This marble, now in the Metropolitan Museum, was 'heavily vandalized' during the French Revolution. Here in the dining room is the bust repurposed to demonstrate moral good.

How long should you be grateful? How sticky is this?

XLV

Dear friend,

There is a quality of light, slivered, silvered, slightly tarnished or greyed. It makes me think of very early summer mornings like today or late afternoons in the autumn.

It always seems to have recently rained when I'm here and so I think of Eugène Atget's photographs of Paris.

The reflections in shop windows, light on stone, the gardens at Versailles and Saint-Cloud, some pedestalled nymph turning away from us, or a great urn and then a shallow run of steps and a sweep of gravel disappearing into the distance, the empty Tuileries. Atget has obsessions. I have just spent a morning looking at all his studies of door knockers and his hundreds of records of beautiful banisters on the turn of the stairs.

This is *l'esprit de l'escalier*. The looking back to say something and finding that they are not there any more, words in your mouth, the riposte held in air.

All that emptiness. Did he wait until they had disappeared? Were there just fewer people in Paris?

Atget was an actor before he damaged his voice and the city is his stage set. People, when they are present, stand on their thresholds of closed shops, of closed doors, waiting for the prompt, for their customer, for their client, for the clunk of the camera shutter.

Or they have just been and now they have gone.

He uses gelatin-silver negative plates with a long exposure time, printing by making contact between the glass negative and light-sensitive paper. The photographs are then washed, gold-toned and fixed before being washed again. They have aura.

You die in November 1935. The ash trees in the park Monceau would have finally lost their leaves. There is a photograph taken from the gallery into the *salon des Huet*. A suite of these photographs was taken in 1936.

The sunlight comes through the windows so it must be afternoon.

The barometer is showing that the weather is set fair. The desk is empty. The chair is pushed back.

This is the house in the act of becoming a museum. It is becoming its record. It has aura.

Exeunt stage right, the words held in the air.

XLVI

Mon cher Monsieur,

On 21 December 1936 there is a ceremony to hand over your house and collections to the Musée des Arts Décoratifs.

It is done beautifully. It is a clear winter day.

Communiqué

In the presence of Monsieur François Carnot, President, and the members of the Conseil d'administration de l'Union Centrale des Arts Décoratifs and many leading members of the world of arts, M. Jean Zay, Minister of Education, inaugurated today at 63, rue de Monceau, the Musée Nissim de Camondo …

After a speech delivered by M. F. Carnot, the Minister responded, expressing to Mme Reinach gratitude for the magnificent generosity of her father. The Minister, conducted by M. Jacques Guerin, was given a tour of the apartments where one finds a remarkable collection which evokes the perfect taste and the sumptuous atmosphere of the second half of the eighteenth century.

The Musée Nissim de Camondo will be open to the public on 29 and 31 December and then thereafter 5 January, on Thursdays, Fridays and Saturdays from 13:00 to 16:00 and on Sundays from 10:00 to 12:30 and then from 14:00 to 16:00.

*

There is an elegant catalogue produced with Musée Nissim de Camondo and your cipher on the cover in red and black. Nissim in uniform faces the title page with his dates below. A short essay by Carle Dreyfus prefaces the book. And then there is a walk through the house with each object faithfully described. There are the photographs of many of the rooms.

And there is a large plaque fixed in the porte cochère unveiled by the Minister of Education, Jean Zay.

LE MUSEE

ANNEXE DU MUSEE DES ARTS DECORATIFS

A ETE LEGUE A LA FRANCE

PAR LE

COMTE MOÏSE DE CAMONDO

1860–1935

VICE-PRESIDENT

DE L'UNION CENTRALE DES ARTS DECORATIFS

EN SOUVENIR DE SON FILS

NISSIM DE CAMONDO

1892–1917

LIEUTENANT AU 2ᴱᴹᴱ GROUPE D'AVIATION

TOMBE EN COMBAT AERIEN

LE 5 SEPTEMBRE 1917

Béatrice is there and Léon and your two grandchildren, Fanny and Bertrand. They are lovely children. Bertrand has a fringe of long hair that he has to keep sweeping from his face. He is thirteen. Fanny is sixteen and is elegantly dressed and looks

uncomfortable in this fuss. She adores horses like her mother, her grandmother.

Her grandmother Fanny Reinach has died and given a huge collection of bronzes to the Musée des Arts Décoratifs in memory of Charles Ephrussi. Théodore Reinach has died and given the Villa Kérylos, the beautiful Greek confection on the Riviera, to the Institut de France. He has also given the Château Reinach – far less beautiful – to the department of Savoie to be used as a school. He understood gratitude, placed it with care in history, finds classical philosophers who share his worldview. He quotes approvingly Philo of Alexandria's declaration that, 'the Jews consider as their "real fatherland" the country they inhabit'. Théodore's final book, *Contre Apion*, translated with his friend Léon Blum, is an edition of the Jewish historian Josephus Flavius' polemical defence of Judaism from the first century. Blum is now the Prime Minister, the first Jewish Prime Minister of France.

Cousin Béatrice Ephrussi Rothschild has died and has given her absurd pink palace at Saint-Jean-Cap-Ferrat, a couple of kilometres away from Kérylos and so much grander, to the Académie des Beaux-Arts.

Your cousin Isaac's donation to the Louvre fills 107 pages of the catalogue they print: Renaissance art and eighteenth-century furniture and Japanese prints and netsuke and then paintings by Cézanne and Corot and eleven works by Degas and seven by Manet and fourteen by Monet. And a painting of fritillaries by van Gogh.

Charles Cahen d'Anvers, the brother of Irène, has given the Château de Champs-sur-Marne to the French nation.

There is a lot to be grateful to the French for.

You are French. Your son gave his life for France and you give France back a perfect *hôtel* filled with 'the decorative arts, one of the glories of France during the period which I love above all other'. The museum is to have his name as this is the house and these are the collections which were destined for him.

And that is the perfectly curated ending: the testament, the instructions, the catalogue, the curator, the old retainers looked after, Béatrice happy to relinquish responsibility. She does not wish to live in a museum.

Happiness of the collector, happiness of the solitary: tête-à-tête with things. Is not this the felicity that suffuses our memories – that in them we are alone with particular things, which range about us in their silence, and that even the people who haunt our thoughts then partake in this steadfast, confederate silence of things. The collector 'stills' his fate. And that means he disappears in the worlds of memory –

writes Walter Benjamin.

The master leaves.

You leave.

MUSÉE
N I S S I M D E
CAMONDO

**UNION CENTRALE
DES ARTS DÉCORATIFS**

XLVII

You would have been pleased, Monsieur.

Le Monde illustré for Saturday 26 December 1936.

There has been an earthquake (illustrated) in San Salvador. The pact between Hitler and Japan is being celebrated enthusiastically in Tokyo. (Photograph of Japanese citizens giving Nazi salute with swastika and Japanese flag.) The Romanian Foreign Minister has been welcomed to Paris. The German support for Franco was discussed. (Photograph of bomb crater in Madrid.) *Imbroligio Chinois*: photograph of Chiang Kai-shek imprisoned. The Duke of Windsor receives photographers to the Château d'Enzesfeld. '*Il est muet. Aucune déclaration.*' The photographers are allowed to watch him play golf. No sign of Mrs Simpson. (Photograph of Duke of Windsor in grey suit.) *Femmes de fer et de caoutchouc*: Miss Dora, blonde, contortionist can squeeze into a fifty-centimetre cube (illustrated).

There is a new museum in Paris writes Carle Dreyfus. (Illustrated with six photographs.)

A folding bicycle has been invented. New ski ware for this season.

Le Monde illustré 'présente à ses abonnés et à ses lecteurs ses meilleurs voeux pour l'année 1937'.

The cover is of Gonet and Big Boy, two chimpanzees playing a violin and a squeezebox.

XLVIII

Neuilly is pleasant and quiet and rich and Léon and Béatrice's duplex apartment looks out directly into the treeline of the Bois de Boulogne. It is opposite an entrance to the park and it takes less than fifteen minutes to walk through the park to l'Étrier de Paris, the stables and riding schools where Béatrice and Fanny keep their horses. Léon's brother Julien has built a rather elegant modern house ten minutes away. He is working on a translation of the *Institutes* of the Roman jurist Gaius: 'The law is what the people order and establish.'

L'Étrier is the place for smart Parisians and their horses. Fanny is seventeen. She keeps a notebook of all her eventing.

She starts *8 oct.'37 (mes débuts). Les Sablons.* It is a *parcours de chasse* in the Bois de Boulogne. She notes every event, the date, her performance. Every photograph is annotated.

Florino – 14 octobre 1937

Florino – 11 novembre 1937

Florino – 15 novembre 1937. Prix des Dames (8/13)

Florino – 18 novembre 1937. (Étrier) 8

Florino – 10 février 1938

Florino – 2 juin 1938. Prix des Dames 3/22

There is hunting in the Halatte to look forward to and riding in the Compiègne forest with the Rothschilds. And more dressage.

In July 1938 there is a series of evening galas at l'Étrier under the patronage of Achille Fould, with jumping and dressage and circus tricks, and then a splendid *'gala costumé, qui permet d'admirer les plus jolies femmes de l'Étrier et les cavaliers les plus reputés dans les costumes de toute beauté'*. Mother and daughter perform.

Bertrand is struggling at school. He wants to train to become an *ébéniste*, to learn how to lay down veneers. All those afternoons in his grandfather's house must have had an influence. In a photograph he holds his dog tightly across his body, smiles.

Léon tries to write sometimes.

And the new Prime Minister, Léon Blum, is dragged from his car and almost killed by members of the Camelots du Roi, the youthful thugs associated with the royalist and anti-Semitic Action Française.

And Xavier Vallat, a member of the National Assembly, states to Blum:

Your coming to power is undoubtedly a historic event. For the first time this old Gallo-Roman country will be governed by a Jew. I dare say out loud what the country is thinking … it is preferable for this country to be led by a man whose origins belong to his soil … than by a cunning Talmudist.

And Louis-Ferdinand Céline, feted, publishes pamphlets on the Jews and what should happen to them. *Bagatelles pour un massacre* is hugely successful and sells 75,000 copies in 1937.

The Musée Nissim de Camondo is hugely popular. There are little red velvet ropes to prevent visitors touching the furniture. They have to extend the opening hours.

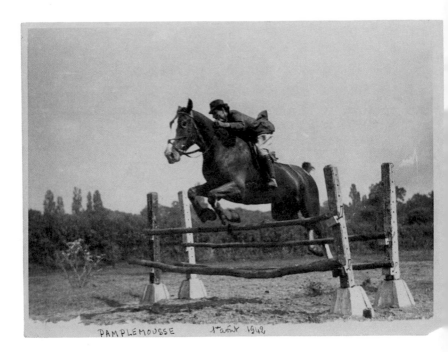

PAMPLEMOUSSE 1er août 1942

XLIX

You are exacting so I'm going to write this as it happened.

L'Exode begins. On 11 June 1940 the French government declares Paris an Open City. On 14 June the Wehrmacht enters Paris unimpeded.

Marshal Pétain, the hero of Verdun, establishes l'État Français in Vichy, the Unoccupied Zone.

On 16 July a denaturalisation law is enacted by the Vichy government.

On 27 September the Germans require a census of all Jews in the Occupied Zone. Under the supervision of the French police, a complete card file of the Jews of Paris is quickly completed.

On 3 October 1940 Pétain makes some changes to strengthen the *statut de Juifs* and then signs it. The Jews are excluded from the army, the press and all government positions. Julien Reinach, just about to be named *conseiller d'État,* is called in by a former colleague and told this is now impossible.

A Jew is defined as 'any person issued from three grandparents of the Jewish race or from two grandparents of the same race, if his/her spouse is himself/herself Jewish'.

Article 8 of the statute has a clause that allows exceptions for Jews who have rendered service to the French state. Béatrice thinks of her brother with his *Légion d'honneur,* of her father's gift to the French people, her uncle's endowment to the Louvre. She thinks

of her *mondaine* friends: she rides with the Marquise de Chasseloup-Laubat and the Comtesse Sauvan d'Aramon. They are friends of Pétain.

On 4 October a law is passed to intern foreign Jews.

Léon entrusts the most valuable part of their art collection to the Musées Nationaux which sends the works to the Château de Chambord for safekeeping. The treasures of the Louvre are stored here.

Otto Abetz, the German Ambassador, draws up a list of Jewish art dealers for the Gestapo. Jacques Seligmann, the Bernheim-Jeune brothers, Paul Rosenberg.

Fernand de Brinon, *délégué général* for the occupied territories, requisitions the house in the rue Rude belonging to the Princesse de Faucigny-Lucinge, an Ephrussi cousin, one of the bridesmaids at Moïse and Irène's wedding.

On 25 October 6,538 Jews are deported from Baden in Germany to the Gurs detainment camp near Pau close to the border with Spain. This camp already holds Spaniards fleeing from Franco and '*les indésirables*'. It is brutal. It is overcrowded and open to the extremities of the weather.

On 11 May 1941 the Institut d'Étude des questions Juives opens in Paul Rosenberg's sequestered gallery at 21 rue la Boétie. Quotations by Drumont and by Pétain are put on the walls. 'The Jews came poor to a rich country. They are now the only rich people in a poor country.' There is help on how to identify Jews with a panel of 'French faces' next to a full-size photograph of Léon Blum.

The Jeu de Paume becomes a warehouse for expropriated art.

On 2 June the *statut de Juifs* is revised and there is now to be a detailed census of all Jews in the Unoccupied Zone. You have

to state your family, religious beliefs, educational attainments and all your property. This new law assigns the date of June 1940 as the last date conversion to Christianity would be considered valid.

On 21 June *numeri clausi* are enacted across the professions, limiting Jews to a certain percentage. Jewish students are to be excluded from university, Jewish doctors are forbidden to practise and Jewish businesses are to be Aryanised. 'It is not expelling them. It is not depriving them of the means of existence. It is merely forbidding them the functions of directing the French soul or French interests,' writes the Vichy Justice Minister Barthélemy in *La Patrie*.

Léon tries to reclaim parts of their art collection that have now been seized from Chambord. He writes on 10 August 1941 from 64 boulevard Maurice Barrès, Neuilly-sur-Seine, to the Director of the National Museums, Jacques Jaujard. Jaujard has been a guest at one of the Louvre luncheons in the rue de Monceau. Léon is most concerned about 'the Renoir portrait of Irène, the mother of my wife'. He mentions that his family and that of his wife have 'considerably enriched the patrimony of their adopted country'.

Jaujard intercedes by sending his letter on to Xavier Vallat, Commissioner General for Jewish Questions in the Vichy government. Vallat's response is a *Non* scribbled in the margin.

Between 20 and 25 August 1941, 4,232 Jewish men are rounded up. They are taken to an internment camp in the north-eastern suburb of Drancy which has been established in a modern housing complex sequestered by the Nazi authorities. This complex is known as *la cité de la muette*, apartment buildings in a U-shape surrounding an open space, two hundred metres long and forty

metres wide. It is guarded by French police. It holds Jews, other prisoners who pose a threat to national security and it also acts as a reserve for hostages who can be murdered in retaliation for attacks on German forces. The food rations are meagre and the sanitation appalling. These buildings have not been completely finished and there are concrete floors and ill-fitting windows.

The rules are arbitrary and punitive. Prisoners cannot move from one stairwell to another, look out of windows. Visitors are prohibited and mail is censored. There is a punishment block in the cellars. Le Bourget and Bobigny have lines that run to Germany and on to Poland.

Le Juif et la France exhibition at Palais Berlitz opens on 5 September 1941 and runs until the New Year. It is organised by the Institut d'Étude des questions Juives. It attracts half a million visitors. There is a catalogue in which Paul Sézille, the Secretary General, writes of wishing to 'convince those of our fellow-citizens who are still of sound mind and good judgment, of the urgency of seeing things as they are and then ... act accordingly'.

In December 1941 the family divides and Léon leaves for the Free Zone. Béatrice and Fanny and Bertrand stay in 64 boulevard Maurice Barrès in Neuilly-sur-Seine. Béatrice and Fanny continue to ride in the Bois de Boulogne.

On 7 February 1942 Jews are forbidden to change their residence or be out at night. On 27 March the first convoy of Jews leaves Drancy for Auschwitz.

On 29 May 1942 Jews are forced to wear a yellow star with the word *Juif.* They have to obtain these from a police station and give proof of address. They have to exchange textile coupons from

their rations for these stars. They are to wear them on the left side of their coat. Jews must only use the last carriage of the Métro. They are banned from public parks, from concerts, from theatres, from restaurants, from swimming pools, the Bois de Boulogne. *Paris-Midi* reports that 'The abundance of Jews on the Paris pavements has opened the eyes of the most blind'.

On 24 June the Prefect of the Meuse writes:

I have the honour to report that two trains carrying Israelites from the Paris region and heading for Germany passed through the Bar le Duc railway station on 22 June. These convoys were made up of men under forty years of age whose hair had been closely cropped. Two cars were filled with girls, the eldest of whom could have been twenty-five years. No incidents to report.

Béatrice and Léon formally separate. Béatrice converts to Catholicism on 1 July 1942 at the Priory Sainte-Bathilde at Vanves.

The Vélodrome d'Hiver round-up begins at 4 a.m. on 16 July 1942. French policemen in 888 teams are allotted to five arrondissements. Fifty buses requisitioned from the Compagnie des Transports. No Germans are to be in evidence. During this day 13,152 Jews are arrested. They can take a blanket, sweater, pair of shoes, two shirts. For five days they are kept in the velodrome. There is little food and water. The sanitation is non-existent and there is squalor. There are 106 suicides and twenty-four people die including two pregnant women.

The arrested Jews are moved on to Drancy. Here there are forty to fifty people in a room and straw to sleep on.

Four thousand children between the ages of two and twelve are separated from their families. Many are too young to know their names. They are entered as question marks on the deportation lists. Many are too small to climb into the cattle trucks and are lifted in. They are deported to Auschwitz.

There are deportation convoys from Drancy to Auschwitz on 22, 24, 27, 29 and 31 July.

On 23 July *Le Matin* states that 'to buy a Jewish household is an excellent investment which carries no risk'.

On 1 August Fanny is photographed jumping on Pamplemousse at l'Étrier. She looks like her mother.

There are thirteen convoys in August.

On 13 August the newspaper *Au Pilori* gives advice about how to denounce Jews:

Numerous readers ask us to which organization they should address themselves in order to point out the occult activities or frauds of the Jews. It is sufficient to post a letter or a simple signed note to the Haut-commissariat aux questions Juives, or failing that, to the offices of our paper for onward transmission.

Their offices are at 43 rue de Monceau, Aryanised from the Kraemer family of art dealers.

The same day radio sets are seized. The following day Jews are forbidden to own bicycles.

On 25 August twenty-six individuals are granted exemption from having to wear the star. The Marquise de Chasseloup-Laubat receives one. Béatrice does not. There are many petitions to the

authorities. Jewish firefighters have to wear the star on their uniforms. Decorated Jewish war veterans should wear the star but not their medals.

On 10 September *Au Pilori* publishes a letter from Céline: 'I have always encouraged defamation, I love it. The most solid stakes and the shortest ropes have always been knocked up that way, I find, absolutely of their own accord.' His new book, *Les Beaux Draps*, is dedicated to '*La corde des pendus*', the rope of the hanged.

[The Jew] sings whatever song you want him to, dances to all types of music … imitating all animals, all races … He's a mimic. Art is only Race and Fatherland! Salvation through the Arts!

In September 1942 Béatrice writes a letter to 'Ma Bonne Moumouche', Madame de Leusse. She is still enjoying riding and is stabling her horse with some new friends.

I am certain that I am miraculously protected, that I have been for years but it is only this year that I have understood from where all my blessings come. But will I have enough years to thank God and the Virgin adequately for their protection? I am such a small thing, and such a novice, so unworthy …

On 26 October 1942 Béatrice and Léon's divorce is ratified. Léon flees to Pau, eighty kilometres from the Spanish border in the Pyrenees. He takes an apartment at 14 boulevard des Pyrénées. It is on the third floor and from the windows you can see the

mountains. The children are still in Paris with their mother. Bertrand is working as an *ébéniste*.

On 8 November Vichy ends the issuing of exit visas to Jews. Three days later German forces cross the demarcation line into the Unoccupied Zone.

In the week of 28 November to 4 December 1942 the harassment of Parisian Jews increases still further.

On 5 December 1942 '*Louise Carmendo, femme Reinac* [*sic*]' and her daughter Fanny are arrested for not wearing the yellow star. They are taken to a commissariat in the 16th arrondissement at 12.30 a.m. They are sent on to Drancy the next day at 3 p.m. There are 2,420 people in the camp.

On arrival Béatrice and Fanny receive the numbers 413 and 415 for Category C1, Jews working in offices, kitchens and infirmary.

A small piece of card states Béatrice is married with two children. No profession. In red ink someone has scribbled '*divorcé 26.10.42*' and crossed out 'Reinach' and written 'de Camondo'.

Fanny Louise Reinach is *célibataire étudiante*.

Both are % *A.A. IV J*. This signifies that all four grandparents are Jews and under this is typed '*à ne pas libérer*'.

Léon and Bertrand are arrested on 12 December a few kilometres from the Spanish border in Ariège. On 3 February 1943 Léon and Bertrand arrive at Drancy. Their cards state that Bertrand is number 414. His domicile is 14 boulevard des Pyrénées, Pau. He has family in the camp. He is a woodworker. He is twenty. Léon is number 1719. Divorced. Two children in camp. Composer.

Béatrice works in the camp kitchens. Fanny in the infirmary. Léon writes music and poetry.

The Director of the Institut de France writes to Fernand de Brinon, *délégué général* for the occupied territories, to plead for Léon's release on 31 March 1943. A month later there is a response from *sig illegible* SS Sturmbannführer:

Paris, 22.4.1943

1. Note:

<u>Re:</u> Opinion on the intervention by the Institut de France via de Brinon in favour of Léon Reinach.

There is nothing on file here about the above person, and he has not hitherto come to notice politically. Reinach himself is not a member of the Institut de France, but the latter is certainly indebted to him for some generous donations. R.'s removal due to the Jewish measures has in no way been detrimental to German interests; the co-signatory of the petition, Duhamel, is known for his hostile and anti-German tendencies. He is the permanent secretary of the Académie Française. In our opinion even de Brinon scarcely supports the petition as he himself has uttered not one word of support for it. We recommend either offering no response or dragging the matter out so that it comes to nothing.

There are new depots for the furniture, art, porcelain, clothing, pianos, children's toys, kitchenware, linen, sequestered from 'abandoned' Jewish apartments across Paris. There are camps at Austerlitz, Levitan. The Cahen d'Anvers house has been taken over to sort Jewish property and is now called, simply, Bassano. '69,619 Jewish dwellings, of which 38,000 are in Paris, have been emptied

of everything in daily or ornamental use.' The Jeu de Paume holds looted artworks for Nazi functionaries to choose from. On 24 December Jacques Jaujard manages to prevent the occupation of the Musée Nissim de Camondo.

On 24 March *Vermerk sur Léon Reinach* is written by section IV B of the Gestapo. It is in German. It summarises the case against them: Bertrand's non-authorised journey into the Unoccupied Zone, his wife and daughter's arrest for not wearing yellow star. And then:

R. possesses typical characteristics of Jew (hooked nose, thin lips, circum-cised, immoral). In addition, he has an insolent and pretentious manner in the camp and we recommend that he is assigned, along with his family, on the next transport of Jews.

Julien and Rita Reinach have been arrested at the Villa Kérylos, taken to Nice and then on to Drancy.

On 3 July 1943 the SS officer Alois Brunner takes over direct command of Drancy from the French authorities with orders to speed up deportations. He institutes daily roll-calls.

In September Léon starts to help dig a tunnel with forty others, organised in three groups. The tunnel is 120 centimetres high and sixty centimetres wide and it is thirty metres long when it is discovered on 9 November. It is three metres away from comple-tion. Fourteen men are deported immediately and in reprisal all those in Category C1 are to be placed in Category B for deporta-tion. On 17 November the cards of Léon, Fanny and Bertrand have the blue C1 crossed out and a red B scribbled over them.

On 20 November 1943 at 11.50 Léon, Fanny and Bertrand are searched and then forced onto Convoy 62 which leaves Gare de Bobigny for Auschwitz. There are 1,200 people in this convoy. On arrival, 914 are murdered. Léon and Bertrand are taken to the camps of Birkenau and Monowitz.

On 31 December 1943 Fanny dies in Auschwitz. She is twenty-two when she is murdered.

Béatrice is still in Drancy. She continues to write to her mother Irène, to arrange for her mother to get the allowance that she and Léon give her. The Comtesse Sampieri is in Paris. She is in touch with Georges Prade, a fixer, a collaborator and friend of Jean Luchaire, publisher of the anti-Semitic *Nouveau Temps*. Prade is seen at the Majestic Hôtel, in the company of members of the French Gestapo and involved in lucrative deals everywhere. He is known as someone who can get people out for the right price. Prade talks on Irène's behalf to Xavier Vallat, the ex-Commissioner-General of Jewish Affairs. Nothing happens.

On 7 March 1944 at 4 a.m. the internees at Drancy are woken and taken to Gare de Bobigny. Béatrice is one of 1,501 people in Convoy 69. There are 178 children in this convoy. It takes three days to reach Auschwitz. They are not given water.

On 22 March 1944 Bertrand dies in the infirmary of Monowitz camp. He is twenty when he is murdered.

On 3 May Julien and Rita Reinach are deported to Bergen-Belsen.

On 4 May there is a commemorative service at Père Lachaise cemetery for the centenary of Edouard Drumont. There are speeches. The heaps of floral tributes almost obscure his bronze

bust. The inscription '*Auteur de l'oeuvre immortelle* La France Juive' has been added to his tomb.

On 12 May 1944 Léon is murdered in Birkenau, two weeks before his fiftieth birthday.

Béatrice is murdered in Auschwitz on 4 January 1945. She is fifty.

17.331 Franç d'orig.

R E I N A C H
Fanny Louise
26.7.1920 Paris 8°
célibataire étudiante

64 bd Maurice Barrès
NEUILLY s Seine

s/% des A?A. IV J à ne
pas libérer

6 DEC 42

128-E — 2306-42

C C

Nom : REINACH

Prénoms : Bertrand

Date Naissance : 1.7-23

Lieu : Paris 16°

Nationalité : Franç. Origine

Profession : Mineur

Domicile : Pau

14 Bd des Pyrénées

C. I. val. jusqu' Menguac 3 2. 43

20 NOV 1943

128-E — 2303-42

Fausl...

17.278

C.C.B

Nom : REINACH

20 NOV. 1942

Prénoms : Léon

Date Naissance : 24.5-93

Lieu : Paris

Nationalité : Frans.

Profession : Camp de Musique

Domicile : Pau

14 Bd des Pyrénées

Div. 2. E

C. I. val. jusqu' Meignac 3.2.43.

17.732 Franç.or

de *CAMONDO*
~~REINACH~~

née de CARMONDO Louise
 Béatrice

9.7.1894 Paris XVI

mariée 2 enf
 Divorcée
sans prof. *le 26.10.42*

64 bd Maurice Barrès

NEUILLY S SEINE

par % A.A. IV J

à ne pas libérer

 6 DEC 42

L

LI

Think that dust settles on the unsettled, debris.

I think of you bringing Nissim back from where he had been buried during the war, that first grave, marked with a cross. You needed him in your family tomb.

I think of Béatrice and Fanny and Bertrand and Léon who cannot come home.

I think of that tunnel.

Ash is a redeemed substance, like dust.

LII

I'm writing to you both.

You were born within a couple of months of each other. There is a photograph of you, my great-grandfather Viktor, in Tunbridge Wells in exile in 1945, with your grandchildren – my father and uncle – in a rose garden, and it reminds me of you, Moïse, with your two grandchildren in a rose garden in the country.

You didn't see it coming, Viktor. You didn't understand the fragility of your vast palais with its endless rooms of possessions and collections, the portraits and emblems. *The Destruction of the Enemies of Zion* is painted in the ceiling of the ballroom. It is a trap. How could you not leave? How you could sit in Vienna and not know that your life was built on such a delicate hope, a bet on assimilation, this slow and steady becoming the person you wanted to be in a place you had grown to love?

I am talking to you, Viktor, scholarly, book-buying, loyal and uxorious, bearded, rabbinical, Virgil-loving, with your loyalty to family, to your father, to Odessa, to Vienna, and to your library. You cannot leave your *chambre du souvenir*, the shelves of the classics bound for you in Paris in red morocco. You love the scent of the lindens in flower outside your study window on the Schottengasse. You are dragged out of your books and your belief in *Bildung*, culture, knowledge, and made to clean the street by

your neighbours. You see Emmy beaten and robbed in front of you and your youngest son threatened with Dachau. You see your library battened into crates and carried down to the courtyard and put onto a lorry. You are dispersed. And Emmy takes her own life. You die as a refugee, stateless.

And you, Monsieur, how could you know?

Your Jewishness is so discreet. It is 1933. Fanny has her bat mitzvah at the Temple Buffault. You give a sizeable donation for the Goncourt exhibition that is being curated. The Goncourts were vile about your family, but they are forgiven. You go to funerals of course but not the festivals. You belong to that great spooling list of clubs. Your generosity is applauded. This summer you take a touring holiday to Venice in your new automobile.

Constantinople is a world away and you are a perfect Frenchman. This is a house of Montrachet, of tisane, the sounds soft on the carpets, percussive on stone. The windows look out beyond the terrace parterre planted with blue ageratums and pink begonias, past the stone Medici vases with their red geraniums, the lawns, the trees your father and uncle planted into a park in the 8th arrondissement of the most civilised city in the world.

You become part of the street, the neighbourhood, the city, the country, so perfectly, so delicately aligned, assimilated, that you disappear. You leave your gift, your name, and go.

LIII

Béatrice, you tried to make conversion work, as it had for your mother, to find safety.

Léon, you tried to make divorce work. You tried to separate your own name of Reinach – Dreyfusard and dangerous – and that of your wife.

And you, Léon, stopped writing and started digging.

From that one gateway in the *la cité de la muette* in Drancy, 67,400 Jews are deported between 22 June 1942 and 31 July 1944.

LIV

So I stood in our old house in Vienna. I'd written the book about my broken Jewish family and it was finally published in German and there was a party. My wife and our two older children were there, and my father aged eighty-one, and Jiro, aged eighty-four, had come from Tokyo to honour Iggie and his exile.

The courtyard was packed. There were people on all the balconies, politicians, journalists, neighbours. And I had to say why this moment mattered. That this was not waiting for someone to give us back what had been stolen, with violence, with terror. That breaking up, our dispersion, our diaspora. That fracture of the four Ephrussi children to four continents of the world, the suicide of their mother, their father a refugee, the murder in the labour camps of uncles and aunts. This wasn't about art. It was what art carries.

This was restitution: a bringing back of something taken.

The courtyard is where a French desk was tipped over the balcony by Viennese neighbours in April 1938 during the first nights of violence. It was given as a wedding present by cousins from that golden hill of the rue de Monceau in Paris, forty years before, lifetimes ago.

This was the first family occasion here since the Anschluss in 1938.

This should be an end, I thought. Let it be.

You make something to be a memorial, but memory is so dangerous. It feeds, it is contingent. You remember one thing and then you are lost. You pick up one thread and it starts to lead you to places you do not want to go. You are in an archive and your heart pauses as you see a name, a crossing-out. Or a survival. You find that Léon's brother, Julien Reinach, jurist, scholar, Commander of the *Légion d'honneur* survived Bergen-Belsen, gravely ill, and that Rita survived too. That he finished his translation of Gaius and published it in 1950.

You find out that the photograph of the unknown, bearded scholar that was on my grandmother Elisabeth's desk and who no one could identify is Théodore Reinach, Léon's scholarly father, part of that fierce trio of know-it-all, *je sais tout* brothers that fought for assimilated French Jewishness. That she kept him within sight wherever she went. Paris, Amsterdam, Vienna, Oberbozen, Tunbridge Wells.

Your house, they say, is a fitting tribute to the memory of Nissim your father and Nissim your son. Walk around the Musée Nissim de Camondo. It is just so.

My book on the collection passed down to me is a fitting tribute to a lost family, naming the dead, saying their names as a way of making it cohere. I make a book, an attempt to try and work out what to pass on. If I can pass on *this* then I am not passing on other responsibilities, that archival weight. I dedicate the book to my father and to my children. It is just so.

But I no longer believe this. It isn't like this: it doesn't work. Tribute and restitution sound like the end, closure.

I do not have clarity today, and I hope that I never will. Clarification would amount to disposal, settlement of the case, which can then be placed in the files of history ... nothing is resolved, nothing is settled, no remembering has become mere memory

writes Jean Améry and I feel this is true. History is happening. It isn't the past, it is a continuing unfolding of the moment. It unfolds in our hands. That is why objects carry so much, they belong in all the tenses, unresolved, unsettling, *essais*.

What can you do? You make your museum and its alignment slips. It does not fit. This golden hill of houses, families from everywhere becoming French, no longer fits either. 61 rue de Monceau is requisitioned as the headquarters of the Milice, the most extreme fascist paramilitary force, created to round up Jews and members of the Resistance. It has 30,000 members.

And I stand in front of the plaque that was unveiled in December 1936 by Jean Zay, the Minister of Education, with Béatrice and Fanny and Bertrand and Léon among all those luminaries, commemorating your gift to France. I have found out that Jean Zay resigned as Minister in 1939 to join the French Army, attempted to join the Resistance in North Africa on the ship *La Massilia*, was arrested, sentenced to deportation and then to internment. And that he was taken from his cell by *miliciens* on 20 June 1944 and murdered in a wood. That he was Jewish. His body was found

under a pile of stones after the war. The only *milicien* charged was released after two years in prison.

There is another, smaller plaque below the great commemorative plaque.

MME LÉON REINACH

NÉE BÉATRICE DE CAMONDO

SES ENFANTS FANNY ET BERTRAND REINACH

DERNIERS DESCENDANTS DU DONATEUR

ET M. LÉON REINACH

DÉPORTÉS EN 1943–1944

SONT MORTS À AUSCHWITZ

Why does being told to move on make me so angry?

LV

Dear Monsieur,

I collect all my family archives – boxes of correspondence, opera books, files on restitution claims, photograph albums of dressing-up parties in Vienna and of cousins on horseback, documents from Odessa and Paris and Vienna, letters from the rabbinate confirming marriages and deaths, the fans found in Iggie's desk in Tokyo after Jiro's death. They are crated and sent off to the Jewish Museum in Vienna. They are a gift.

I take two-thirds of the netsuke collection in an attaché case to Vienna as a long-term loan to the museum, so that they can tell the story of my family who came from Odessa to Paris and Vienna and on to Tunbridge Wells and Tokyo and Mexico and Arkansas. And one-third we sell at auction to raise money for the Refugee Council.

It is an attempt to avoid elegy. I don't need to live with this. I don't need to pass this on.

LVI

A final visit, Monsieur.

By myself. Walking across the hall and up the staircase. At the turn of the stairs is the Chinese vase you kept from your parents' house. Up and into the bureau. The suite of tapestries, your half, the other half bought by Jules Ephrussi for his *hôtel*.

I've been looking at the photographs published in *L'Illustration* the week the house became a museum. There are no little ropes channelling the visitor through the rooms. No discreet numbers so we can check what is what against the guide. The blinds are down, as they should be, so light cannot damage these tapestries. It is free of dust.

I'm quiet as I don't want to disturb this room, you. I remember Proust writing of the indifference of photography, the brief moment when true witness is possible:

Of myself – thanks to that privilege which does not last but which one enjoys during the brief moment of return, the faculty of being a spectator, so to speak, of one's own absence – there was present only the witness, the observer, with a hat and traveling coat, the stranger who does not belong to the house, the photographer who has called to take a photograph of places which one will never see again. The process that mechanically occurred in my eyes when I caught sight of my grandmother was

indeed a photograph … For the first time and for a moment only, since she vanished at once, I saw sitting on the sofa, beneath the lamp, red-faced, heavy and common, sick, lost in thought, following the lines of a book with eyes that seemed hardly sane, a dejected old woman whom I did not know.

This is what happens in your house. I think of the two photographs of Fanny and Bertrand, taken one after another, smiling, legs tucked up in a chair. They are both in school uniform. I think of the photograph of Bertrand holding his dog, kissing her.

We become spectators of absence, strangers who do not belong in the house.

LVII

Monsieur,

Enough, I know, and this might seem ridiculous and a return to stuff we have discussed but I do need to talk to you about portraits.

Louise Cahen d'Anvers didn't care much for those two portraits that Renoir did of her daughters, all that trouble Charles went to. The double portrait of the younger girls in their pink and blue party dresses was dispatched to a maid's room. And then sold to the Bernheims for their private collection in 1900. She made Renoir wait for his money too, which isn't a great footnote in art history. But she gave the portrait of Irène to her granddaughter Béatrice. When she married Léon the portrait hung in their apartment in Neuilly.

It becomes famous. It is exhibited and reproduced. Irène becomes *La Petite Irène*. In 1933 it is shown at the great Renoir exhibition at the Orangerie.

And in the tumult of 1939 it is taken to the Château de Chambord. It is then 'confiscated' by the Einsatzstab Reichsleiter Rosenberg, the body that loots, dispossesses Jews from everything they own. On 10 August 1941 Léon writes a letter to the Direction des Musées nationaux, Paris, says the painting has been given to

his wife by her grandmother, emphasising just how much the family has given to France.

Goering chooses it for his private collection at Carinhall. Frau Emmy Goering has a weakness for the Impressionists and this girl is enchanting. As the critic wrote when it was exhibited at the salon in 1881, 'One cannot dream of anything prettier than this blond child, whose hair unfolds like a sheath of silk bathed with shimmering reflections and whose blue eyes are full of a naïve surprise.' She could be Gentile: she has become *La Petite Fille au ruban bleu.* And it isn't a very big painting, a little over two feet high by one and a half wide, easy to hang.

Goering then trades it for a Florentine Tondo to Gustav Rochlitz, an art dealer working with the Einsatzstab Reichsleiter Rosenberg, on 10 March 1942.

Jewish family portraits in the Jeu de Paume are destroyed by the Gestapo in 1944.

On 4 September 1945 it is recovered and transferred to Munich Central Collecting Point no. 8035 and shipped back to Paris where it is exhibited in *Les chefs-d'œuvre des collections privées françaises retrouvés en Allemagne par la Commission de récupération artistique et les Services alliés* at the Tuileries in 1946, the exhibition of French masterpieces found in Germany. It is back in the Orangerie.

Irène Sampieri, née Cahen d'Anvers, mother of Béatrice, grandmother of Fanny and Bertrand, your ex-wife, Catholic, claims it on behalf of the estate of her late daughter on 27 March 1946. She has now become the heir of the Camondos.

She sells the portrait that Renoir painted of her in 1880 in the gardens of the Hôtel Cahen d'Anvers in the rue de Bassano. It is then sold on to Emil Georg Bührle, the Swiss owner of Oerlikon, supplier of armaments to the Nazis.

She inherits her daughter's fortune of 110 million francs. In the 1950s she buys the Villa Araucaria in Cannes. She dies in November 1962 in the 16th arrondissement.

Her younger sister Elisabeth, the girl in the blue dress in *Rose et bleu*, dies during her deportation to Auschwitz in March 1944. Her sister Alice, in the pink dress, dies in Nice in 1965.

Portrait of Irène Cahen D'Anvers (La Petite Irène) is in the Fondation Bührle in Zurich.

Rose et bleu is in the Museu de Arte de São Paulo.

People slip into art and are lost.

LVIII

So, Monsieur, when my book on my family came out I was asked about faith. In America, with some directness, I was asked, 'Are you coming back?' Some asked about the children. I deflected.

And my father is a half-Jewish Anglican clergyman. My mother is the daughter of a country vicar, a historian, a writer on monasticism. I've been brought up in the Church of England, in cathedrals. I've written about the Quakers and am drawn to their silences. I read Zen Buddhist poetry. I love the psalms as they cross over everything, are proper poems of exile. I am half-English and a quarter Dutch and a quarter Austrian and completely European.

I'm not sure what I am coming back *to*.

The statement *ce que nous sommes* becomes a question. My father, born in Amsterdam, raised in Paris, Vienna and the Tyrol, a refugee in 1939, has been told his application to become an Austrian citizen has been successful. It is eighty-two years since he left Vienna. But where do I belong? I use porcelain which is a migratory material. It has come a long way. I make things that are susceptible to breakage. I stand up and tell stories. I write, but now when I write I think of palimpsests, the writing over of one text by another. I seem to spend a lot of time in archives. I remember that Salomon Reinach in his book *Drumont et Dreyfus*

used the nom de plume of *l'archiviste* and I think there is great honour in archivists.

I think I'm a mongrel. I'm a lapsed everything. But I do know what commitment to an idea looks like. I know that there are ways of making something extraordinary out of dispersion. And that this is a way of saying something, of countering the silence of disdain.

I think you can love more than one place. I think you can move across a border and still be a whole person.

So I sit here in this beautiful room with the carpet of the golden winds under my feet on the edge of the Parc Monceau and think *ce que nous sommes*, that you can make a place a home and there is honour in that and I think this is witness. This is what I'm coming back to.

I can sense autumn.

I think *friend*.

<div align="right">

Edmund de Waal
London, December 2020

</div>

FURTHER READING

Essential reading on the Camondo family is Nora Şeni and Sophie Le Tarnec, *Les Camondo ou l'éclipse d'une fortune*, Arles, Actes Sud, 1997 and Pierre Assouline, *Le Dernier des Camondo*, Paris, Gallimard, 1997. A wonderful exhibition catalogue on the family is *La Splendeur des Camondo de Constantinople à Paris 1806–1945*, Paris, Musée d'art et d'histoire du Judaïsme, 2009. The key book on the creation of the Museum is the beautifully illustrated *Musée Nissim de Camondo: La demeure d'un collectionneur*, Paris, Musée des Arts Décoratifs, 2007, republished in English as *The Camondo Legacy: The passions of a Paris Collector*, London, Thames & Hudson, 2008. The recent publication of Nissim's letters is invaluable: *Le Lieutenant Nissim de Camondo Correspondance et Journal de Campagne 1914–1917*, Paris, Les Arts Décoratifs, 2017. Anne Sebba, *Les Parisiennes*, New York, St Martin's Press, 2016 has a substantial chapter on Beatrice Reinach. James McAuley's magisterial book *The House of Fragile Things*, New Haven, Yale University Press, 2021 gives great depth to the history of Jewish collectors in France and is highly recommended.

For the background to Jewish life in France I am indebted to Pierre Birnbaum, trans. Jane Marie Todd, *The Jews of the Republic*, Stanford, Stanford University Press, 1996 and to Michael Graetz, trans. Jane Marie Todd, *The Jews in Nineteenth-Century France*,

Stanford, Stanford University Press, 1996. Cyril Grange, *Une élite parisienne: les familles de la grande bourgeoisie juive (1870–1939)*, Paris, CNRS Editions, 2016 is essential to understand the economic milieu.

On the development of the Rue de Monceau I recommend Fredric Bedoire, *The Jewish Contribution to Modern Architecture 1830–1930*, Stockholm, 2004 and for the building of Villa Kerylos, Adrien Goetz, *Villa Kérylos*, Paris, Grasset, 2019, translated as *Villa of Delirium*, New York, New Vessel Press, 2019.

Two terrific recent novels have retraced part of this story: Fillipo Tuena, *Le variazioni Reinach*, Rome, SuperBEAT, 2015 and Adrien Goetz, *Villa Kérylos*.

For background reading on taste and connoisseurship I recommend Charlotte Vignon, *Duveen Brothers and the Market for Decorative Arts, 1880–1940*, New York, D. Giles Ltd, 2019 and Colin B. Bailey, *Renoir's Portraits: Impressions of an Age*, New Haven, Yale University Press, 1997.

Finally, the key texts that I have used in reference to Vichy France and the Holocaust are Michael R. Marrus and Robert O. Paxton, *Vichy France and the Jews*, New York, Basic Books, 1983; David Pryce-Jones, *Paris in the Third Reich,* London, HarperCollins, 1981; Sarah Gensburger, *Images d'un Pillage: Album de la spoliation des juifs a Paris, 1940–1944*, Paris, Textuel, 2010; Renée Poznanski, *Jews in France during World War II*, Waltham, MA, Brandeis University Press, 2002; Robert Paxton, *La France de Vichy (1940–1944)*, Paris, Points Histoire, 1973; and Alan Riding, *Et la fête continue: la vie culturelle à Paris sous l'Occupation*, Paris, Flammarion, 2012.

NOTES

Epigraph

p. vii **lacrimae rerum** 'tears of things', from '*sunt lacrimae rerum et mentum mortalia tangunt*', 'there are tears of things and mortal things touch the mind', Virgil, *Aeneid*, Book 1, line 462.

Letter III

p. 6 **where your Sèvres services** ... See Sylvie Legrand-Rossi, *Les Services aux oiseaux Buffon du comte Moïse de Camondo: Une encylopédie sur porcelain*, Les Arts Décoratifs/Gourcuff Graden, 2016.

Letter V

p. 10 **the carpet of the winds** ... Bertrand Rondot, 'Bâtir une collection', in Marie-Noël de Gary, *Musée Nissim de Camondo: La demeure d'un collectionneur*, Paris, MAD, 2007, p. 87. In fact, Juno and Aeolus were removed when the carpet was cut down.

Letter VI

p. 12 **a 'stone house'** ... Nora Şeni and Sophie Le Tarnec, *Les Camondo ou l'éclipse d'une fortune*, Arles, Actes Sud, 1997, pp. 9–42.

p. 13 **'Instructions and advice ...'** De Gary, *Musée Nissim de Camondo*, p. 273.

Letter VII

p. 16 **'a dense, grey velvety dust ...'** John Rewald, *Morandi*, New York, Albert Loeb & Krugier Gallery Inc., 1967.

Letter VIII

p. 18 **'Ash ... the very last product ...'** Sarah Kafatou, 'An Interview with W. G. Sebald', *Harvard Review*, No. 15 (Fall, 1998), pp. 31–5.

Letter X

p. 25 **'the great dames of the noble Faubourg ...'** George Augustus Sala, *Paris Herself Again*, New York, Scribner and Welford; 6th Edition, 1882.

Letter XI

p. 28 **at number 61 ...** See exhibition pamphlet, 'Le 61 rue de Monceau: L'autre hôtel Camondo', Sylvie Legrand-Rossi and Sophie d'Aigneaux-Le Tarnec, Paris, MAD, 2020.

p. 28 **'still-new and pale' house ...** Émile Zola, *La Curée* (1871), Paris, Gallimard, Folio, 2005, p. 28.

p. 29 **'the site plan of deadly traps ...'** Walter Benjamin, *Selected Writings Volume 1, 1913–1926*, ed. Michael W. Jennings, Howard Eiland, Gary Smith, Cambridge, Harvard University Press, 2004, p. 446.

p. 29 **'on summer nights . . .'** Émile Zola, *La Curée* (1871), vol. I, Paris, Gallimard, Bibliothèque de la Pléiade, 1961, p. 332.

p. 29 ***Le Baron Vampire*** For Guy de Charnacé, *Le Baron Vampire*, Paris, 1885, cf. Sarah Juliette Sassoon, *Longing to Belong: The Parvenue in 19th Century French and German Literature*, New York, Palgrave Macmillan, 2012, p. 107.

Letter XII

p. 32 **'golden, like the painting . . .'** Edmond de Goncourt, *Journal des Goncourt*, Tome sixième 1878–1884, Paris, 1892, p. 108.

p. 32 **'*La muse alpha*'** Michael Mansuy, *Un Moderne: Paul Bourget de l'enfance au Disciple*, Paris, Les Belles Lettres, 1968, p. 287.

p. 33 **'Yes, there are two . . .'** Paul Bourget, *Cosmopolis*, New York, Current Literature Publishing Company, 1910, p. 219.

p. 34 **Charles persuades Louise ...** Colin B. Bailey, *Renoir's Portraits: Impressions of an Age*, New Haven and London, Yale University Press, in association with National Gallery of Canada, 1997, pp. 11–15, 181–3.

Letter XIV

p. 38 **Mes chéris ...** Şeni and Le Tarnac, *Les Camondo ou l'éclipse d'une fortune*, p. 206.

Letter XV

p. 39 **'*Les Rothschilds* ...'** Edouard Drumont, *La fin d'un monde*, Paris, Nouvelle Librairie Parisienne, 1889, p. xxxi.

p. 40 **'with Reinach beaten ...'** Pierre Birnbaum, trans. Jane Marie Todd, *The Jews of the Republic*, Stanford, Stanford University Press, 1996, pp. 7–19, 151–3.

p. 40 **judicial murders, ...** Salomon Reinach, *Orpheus: histoire générale des religions*, London, Heinemann, 1909, p. 4.

p. 42 **'silence of disdain'** ... Théodore Reinach, 'Actes', *Revue des études Juives*, vol. 15 (1885), p. 132, quoted in *Jewish Emancipation Reconsidered: the French and German Models*, ed. Michael Brenner, Vicki Caron and Uri R. Kaufmann, Tübingen, Mohr Siebeck, 2003, p. 142.

p. 42 **'you can't turn to some Leven or Reinach ...'** Birnbaum, *The Jews of the Republic,* pp. 16–17.

Letter XVI

p. 44 **'the spectacle of all those bearers ...'** Drumont, *La France Juive,* vol. II, p. 81.

Letter XVII

p. 46 **you donate the ornamental plaque for the Torah** ... *La Splendeur des Camondo de Constantinople à Paris 1806–1945*, Musée d'art et d'histoire du Judaïsme, exhibition, Paris, Flammarion, 2009, pp. 124–9.

Letter XVIII

p. 48 **les épingles de cravate** ... Évelyne Possémé, 'Les épingles de cravate du comte Nissim de Camondo', in ibid., pp. 120–1.

p. 49 **'cufflinks, buttons ...'** de Charnacé, *Le Baron Vampire*, 1885, quoted in Sassoon, *Longing to Belong,* p. 42.

Letter XX

p. 54 **Achille Duchêne designs your gardens for you** ... De Gary, *Musée Nissim de Camondo: La demeure d'un collectionneur*, pp. 267–71.

Letter XXI

p. 56 **Proust loves Chardin** ... Marcel Proust, *Chardin and Rembrandt*, New York, David Zwirner Books, 2016. For a discussion of Proust's essay

see also Helen O. Borowitz, 'The Watteau and Chardin of Marcel Proust', *The Bulletin of the Cleveland Museum of Art*, vol. 69, no. 1 (Jan., 1982), pp. 18–35.

Letter XXII

p. 60 **'memory weaves, unweaves the echoes'** ... Octavio Paz, trans. Elizabeth Bishop, in *Objects and Apparitions*, New York, Tibor de Nagy Editions, p. 201.

Letter XXIII

p. 62 **your porcelain room** ... Cf. Legrand-Rossi, *Les Services aux oiseaux Buffon du comte Moïse de Camondo.*

Letter XXIV

p. 64 *'Élève intelligent...' Le Lieutenant Nissim de Camondo Correspondance et Journal de Campagne 1914–1917*, Les Arts Décoratifs, 2017, p. 12.

Letter XXV

p. 65 **If you go to Seligmann's** ... See Charlotte Vignon, *Duveen Brothers and the Market for Decorative Art, 1880–1940*, New York, Frick Collection in association with GILES, 2019.

p. 67 **'The love of bric-a-brac, ...'** Drumont writing on Château de Ferrières in *La France Juive*, 'Un prodigieux, un incroyable magasin de bric-a-brac.' Also quoted in *Le Lieutenant Nissim de Camondo*, p.10.

Letter XXVI

p. 70 **'You keep the 268 letters and postcards ...'** *Le Lieutenant Nissim de Camondo Correspondance et Journal de Campagne 1914–1917*, p. 194.

p. 72 **'I learn with deep sadness ...'** Ibid., p. 249.

Letter XXVII

p. 73 **you write in your will** ... Sylvie Legrand-Rossi, 'Un musée en mémoire', in *Le Lieutenant Nissim de Camondo Correspondance et Journal de campagne*, p. 34.

Letter XXIX

p. 78 *'ce que nous sommes'* ... Théodore Reinach, *Ce que nous sommes*, Paris, Union Libérale Israelite, 1917, reissued 2018, Paris, Hachette, p. 11.

Letter XXX

p. 80 **'Perhaps,' writes Walter Benjamin ...** Walter Benjamin, trans. Howard Eiland and Kevin McLaughlin, *The Arcades Project*, Cambridge, Harvard University Press, 1999, p. 211.

p. 80 **'almost unobtainable objects'** Charles Ephrussi, 'Les Lacques Japonais au Trocadero', *Gazette des beaux-arts*, pp. 954–68.

p. 81 **'And I had already lived ...'** Marcel Proust, *The Past Recaptured*, in *Remembrance of Things Past*, vol. 2, New York, Random House, 1932, p. 1070.

Letter XXXI

p. 84 **Villa Kérylos ...** A beautiful recent book on the house is Adrien Goetz, *Kérylos*, Paris, Grasset, 2019.

Letter XXXII

p. 87 **The Sonata for piano ...** *Menestrel*, 19 March 1926, quoted in Fillipo Tuena, *Le variazioni Reinach*, Rome, SuperBEAT, 2015, p. 361.

Letter XXXVI

p. 98 **'Happiness of the collector ...'** Benjamin, *The Arcades Project*, p. 866.

p. 98 **definitions for the crafts ...** ed. Diderot, *Encyclopédie, ou dictionnaire raisonné des sciences, des arts et des métiers*, Paris, 1751–1772.

Letter XXXVII

p. 100 **'too much exertion ...'** quoted in Mitchell B. Merback, *Perfection's Therapy: An Essay on Albrecht Dürer's* Melencolia I, New York, Zone Books, 2017, p.15. The quote is taken from Dürer's unfinished work, *Ein Speis der Malerknaben*, 'Nourishment for Young Painters' (*c.* 1512).

p. 100 **'came into the world ...'** Walter Benjamin, *One-Way Street and Other Writings*, London, Verso, 1985, p. 8.

p. 100 **The world of mourning concludes ...** See Sigmund Freud, *On Murder, Mourning and Melancholia*, London, Penguin Modern Classics, 2005.

Letter XXXVIII

p. 105 **'He may even become ...'** Joseph Roth, trans. Michael Hofmann, *The Wandering Jews*, London, Granta, 2001, p. 82.

Letter XL

p. 110 **discussed at dinner ...** Proust, *The Guermantes Way*, in *À la recherche du temps perdu*, ed. Jean-Yves Tadié, Paris, Pléiade, 1987–9, Volume II, pp. 790–1.

p. 111 **'this work has yet to develop ...'** From 'On the Theory of Knowledge, Theory of Progress', in Benjamin, *The Arcades Project*, p. 458.

Letter XLI

p. 115 **'The shape of my library is round ...'** Michel de Montaigne, 'Of Three Kinds of Association', in *The Complete Essays*, trans. M. A. Screech, London, Penguin, 1993.

Letter XLIII

p. 118 *Histoire des Israélites ...* Théodore Reinach, *Histoire des Israélites depuis l'époque de leur dispersion jusqu'à nos jours*, Paris, Hachette, 1885, pp. 325–6.

Letter XLIV

p. 119 **a bronze cast after a model by Houdon ...** De Gary, *Musée Nissim de Camondo*, pp. 288–9, illustration on pp. 185–6.

Letter XLVI

p. 124 *Communiqué ... Excelsior*, 24 December 1936, https://gallica.bnf.fr/ark:/12148/bpt6k4609794h/f2.item

p. 127 **Happiness of the collector ...** Benjamin, *The Arcades Project*, p. 866.

Letter XLVIII

p. 130 **He is working on a translation ...** Julien Reinach, *Gaius, Institutes*, Paris, Société d'Édition "Les Belles Lettres", 1950. https://en.wikipedia.org/wiki/Gaius_(jurist) 'The law is what the people order and establish', Gaius, *Institutiones, 1.2.3.*

p. 131 *'gala costume, qui permet ...'* Quoted in Tuena, *Le variazioni Reinach*, p. 111.

p. 131 **'Your coming to power ...'** Quoted in Pierre Birnbaum, trans. by Arthur Goldhammer, *Léon Blum: Prime Minister, Socialist, Zionist*, New Haven, Yale University Press, 2015.

Letter XLIX

p. 133 **'any person issued'** Richard Weisberg, *Vichy Law and the Holocaust in France*, New York, New York University Press, 1996, p. 59.

p. 135 **'It is not expelling them …'** Michael R. Marrus and Robert O. Paxton, *Vichy France and the Jews*, New York, Basic Books, 1983, p. 99.

p. 135 **'the Renoir portrait of Irène, …'** *La Splendeur des Camondo de Constantinople à Paris 1806–1945*, Paris, Musée d'art et d'histoire du Judaïsme, 2009, p. 105.

p. 136 **'There is a catalogue …'** David Pryce-Jones, *Paris in the Third Reich*, London, HarperCollins, 1981, p. 138.

p. 137 **'The abundance of Jews …'** Ibid., p. 138.

p. 137 **'I have the honour to report …'** Michael R. Marrus and Robert O. Paxton, *Vichy France and the Jews*, p. 216–7.

p. 138 **'to buy a Jewish household …'** Ian Ousby, *Occupation: The Ordeal of France 1940-1944*, London, John Murray, 1997, p. 146.

p. 138 **'Numerous readers …'** *Au Pilori*, no. 109, 13 August 1942, http://www.memorialdelashoah.org/wp-content/uploads/2016/05/au-pilori-inventaire-bibliotheque.pdf.

p. 139 **'I have always encouraged …'** Pryce-Jones, *Paris in the Third Reich*, p. 56.

p. 139 **'I am certain that I am miraculously …'** Anne Sebba, *Les Parisiennes*, New York, St Martin's Press, 2016, pp. 141–2.

p. 141 **The Director of the Institut de France writes …** Tuena, *Le variazioni Reinach*, p. 234.

p. 141 **The Cahen d'Anvers house …** For photos of the house being used as a depot, see Sarah Gensburger, *Images d'un Pillage: Album de la Spoliation des Juifs à Paris, 1940–1944*, Paris, Éditions Textuel, 2010.

p. 142 ***Vermerk sur Léon Reinach …*** *La Splendeur des Camondo*, p. 155.

Letter LII

p. 151 ***The Destruction of the Enemies of Zion***... See Gabriele Kohlbauer-Fritz and Tom Juncker, *Die Ephrussis: Eine Zeitrese*, Jewish Museum, Vienna, Paul Zsolnay Verlag, 2019, pp. 86–93.

Letter LIV

p. 156 **'I do not have clarity today ...'** Jean Améry, *At the Mind's Limits*, London, Granta 1966, p. xi.

Letter LVI

p. 159 **'Of myself ...'** Proust, *The Guermantes Way*, p. 155.

Letter LVII

p. 163 **'One cannot dream of anything prettier ...'** For discussion of Renoir's portraits of the Cahen d'Anvers daughters, see Bailey, *Renoir's Portraits*, pp. 181–3, 306–7.

p. 163 **She has now become the heir of the Camondos ...** Cyril Grange, *Une élite parisienne: les familles de la grande bourgeoisie juive (1870–1939)*, Paris, CNRS Éditions, 2016, pp. 144–5.

Letter LVIII

p. 166 ***Drumont et Dreyfus*** ... Salomon Reinach, *Drumont et Dreyfus. Études sur la "Libre Parole" de 1894 à 1895,* Paris, Stock, 1898.

LIST OF ILLUSTRATIONS

All illustrations are from the archives of the Musée Nissim de Camondo © MAD, Paris / Jean-Marie del Moral unless otherwise stated. Pages 5, 15, 23, 58, 89, 93, 95, 109, 161 © MAD, Paris / Christophe Dellière.

p. 2 Carriage porch entrance of the Musée Nissim de Camondo, 63 rue de Monceau, Paris

p. 5 Red leather-bound books of correspondence from the bank of Isaac Camondo & Cie, 1880–1890, in the archives of the Musée Nissim de Camondo

p. 9 The Comte Moïse de Camondo, c. 1890

p. 11 The carpet of the winds in *le grand salon* and a detail of a late eighteenth-century pedestal table in the Musée Nissim de Camondo

p. 15 View of the carriage porch entrance of the Musée Nissim de Camondo towards the courtyard

p. 23 Door to the old trunk room

p. 27 Map of Paris: Karl Baedeker, *Baedeker's Paris and its Environs*, Leipzig, 1898

p. 31 The *grand salon* of the *hôtel* at 61 rue de Monceau, c. 1876

p. 38 Irène Cahen d'Anvers and her children, Béatrice and Nissim Camondo and Claude Sampieri, c. 1905

p. 41 Théodore Reinach, 4 May 1913: Photographie agence de presse Meurisse © Bibliothèque Nationale de France

p. 45 Moïse, Béatrice and Nissim de Camondo in Aumont, c. 1910

p. 51 Table *à la Bourgogne*, Roger Vandercruse, known as Lacroix, c. 1760

p. 53 Plan of the high ground floor of the Hôtel Camondo, René Sergent: Excerpt from René Bétourné, *René Sergent architecte, 1865–1927*, Paris, Horizons de France, 1931, p. 20 © MAD, Paris

p. 58 *Jeune Fille au volant*, François Bernard Lépicié, in the style of Jean Siméon Chardin, engraving, 1742, hanging in the corridor of the Musée Nissim de Camondo

p. 61 Table set for dinner in the porcelain room

p. 66 A chest of drawers with sliding panels, Jean-Henri Riesener, *c.* 1775–1780; and a nineteenth-century *Bacchanale* in the style of Clodion, artist unknown

p. 69 Moïse de Camondo and his son, Lieutenant Nissim de Camondo, in the summer of 1916, in the garden of 63 rue de Monceau

p. 76 Nissim de Camondo's bedroom

p. 82 The front courtyard of the Villa Kérylos, designed by Emmanuel Pontremoli, photographed by Antoine Vizzanova: Published in *Kérylos*, Paris, Éditions des Bibliothèques nationales de France, 1934. Photo © Benjamin Gavaudo / Centre des monuments nationaux

p. 85 The Villa Kérylos seen from the beach, photographer unknown, 1950s postcard

p. 89 Léon Reinach, 1933

p. 93 Béatrice Reinach, 1933

p. 95 *Duchesse brisée, c.* 1740–1750, in the blue drawing room at the Musée Nissim de Camondo

pp. 102–3 Moïse de Camondo's library

p. 109 The pantry of the dining room, the domain of Pierre Godefin, head butler to Moïse de Camondo

pp. 122–3 View from the gallery into the *salon des Huet*, 1936: Archives of the Musée Nissim de Camondo © Alain Moïse Arbib

p. 128 Catalogue of the Musée Nissim de Camondo, 1936

p. 132 Fanny Reinach on Pamplemousse, 1 August 1942

pp. 145–8 Deportation cards of Fanny, Bertrand, Léon and Béatrice Reinach, taken from the Drancy internment camp file, after 1942 © Archives nationales, France

p. 161 Bertrand Reinach, 1938

p. 165 *Portrait de mademoiselle Irène Cahen d'Anvers*, Pierre-Auguste Renoir, 1880 © Emil Bührle Collection, Zurich / Photo Schälchli/Schmidt, Zurich

p. 168 Garden of the Musée Nissim de Camondo

ACKNOWLEDGEMENTS

I am enormously grateful to Olivier Gabet, the Director of the Musée des Arts Décoratifs, for his great friendship and for his trust in opening the doors of the Musée Nissim de Camondo to me. Sophie Le Tarnec, Sylvie Legrand-Rossi, Chloé Demey, Anaïs Lancrenon, Lionel Leforestier and Yvon Figueras have been truly warm and supportive of this whole project: this book could not have been realised without their knowledge and generosity. Thank you all so much.I am deeply indebted to you all.

My deep gratitude, as always, to my marvellous editor Clara Farmer and to Charlotte Humphery at Chatto & Windus, to Kathy Fry and Fiona Brown for their care with the text and Stephen Parker for his beautiful design. Thank you once again to Jonathan Galassi and Ileene Smith at FSG for their enthusiasm for another book. Thank you so much to my agent Caroline Wood, to Zoe Pagnamenta and to Andrew Nurnberg, who made this book happen in truly challenging times. I am exceptionally fortunate to be working with you all.

Thank you to Marina Kellen French, Samia Samou, Brigitte Hilzensauer, Renata Goldschmidt-Propper, Giselle de Bogarde Scantlebury and Anne Sebba for Parisian introductions, translations and conversations along the way. I want to thank both of my parents for conversations on origins, belonging and moving on. Claire Tillotson

has been indefatigable from the start, careful and discerning and truly imaginative in helping this book on its journey. My team, Melody Clark, Stephanie Forest, Sun Kim, Chris Riggio and Barry Stedman, led by my studio director Jemima Johnson, have been terrific.

My first reader was my daughter Anna who was hugely encouraging and perceptive, noticing and commenting on everything with generous acuity. My deepest gratitude goes to my family, to my wife Sue and to Ben and Matthew and Anna for believing in this book and for their love.

This book is for Felicity Bryan. She was my friend and my literary agent for fifteen years and unlocked books and possibilities with wonderful energy and love. I told her about these letters in her last weeks, her husband Alex Duncan read them aloud to her, and she said that it would be her last book deal. It was and I miss her.